NATURAL ARCHITECTURE NOW

NATURAL ARCHITECTURE NOW

NEW PROJECTS FROM OUTSIDE THE BOUNDARIES OF DESIGN

FRANCESCA TATARELLA

Princeton Architectural Press · New York

Princeton Architectural Press
37 East 7th Street
New York, New York 10003
www.papress.com

22 Publishing srl
via Morozzo della Rocca, 9
20123 Milan
www.22publishing.it

For 22 Publishing
Series Director: Francesca Tatarella
Book design: No11, Inc.
Editor: Margherita Fenati

22publishing dedicates this book to the memory of Giovanni Russo,
art director and founder of No11, who was deeply involved with
the design of the first volume of *Natural Architecture*.

Image credits, cover:
Doug and Mike Starn (front), Patrick Dougherty (back)

For Princeton Architectural Press
Editors: Nicola Bower and Jay Sacher
Cover design and english typesetting: Paul Wagner
Translation: Natalie Danford

Library of Congress Cataloging-in-Publication Data
Tatarella, Francesca
Natural architecture now : new projects from outside the boundaries
of design / Francesca Tatarella.—
First [edition].
 pages cm
ISBN 978-1-61689-140-4 (pbk.)
1. Site-specific installations (Art) 2. Nature (Aesthetics) 3. Environment
(Art) 4. Plants in art. 5. Art, Modern—21st century.
N6498.I56N38 2014
709.04'074—dc23
 2013033941

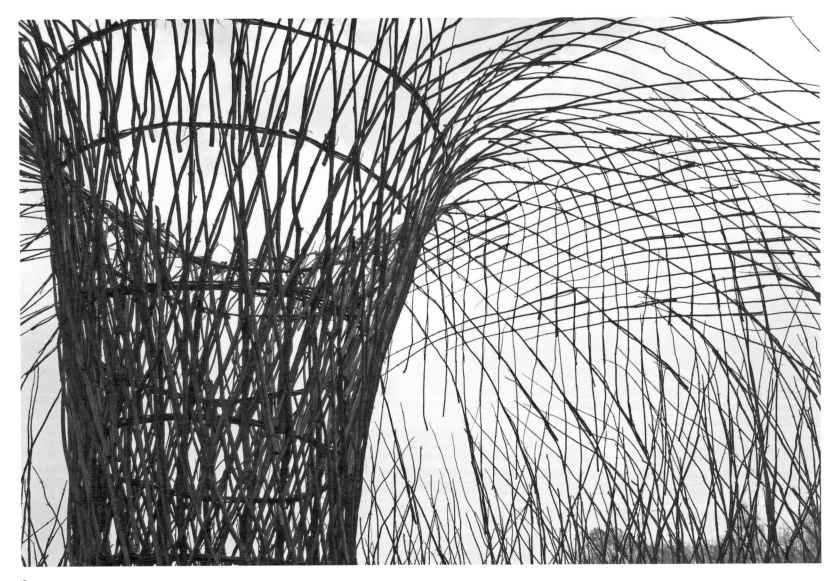

This book is dedicated to Giuliano Mauri, tree
weaver, who passed away in 2009 and
whose input during the editing of the first volume
of *Natural Architecture* was invaluable.

Aviary for Humans (Voliera per umani) Giuliano
Mauri
Monza Park, Italy, 2006
Diameter 66 feet, height 33 feet, 8,000 branches
(diameter 20 meters, height 10 meters)

*"It will be there for many years. Then the knots
will loosen, the timber will go slack, and the whole
thing will become a trace of itself, a memory
of its existence."*
—Giuliano Mauri, tree weaver, www.giulianomauri.com

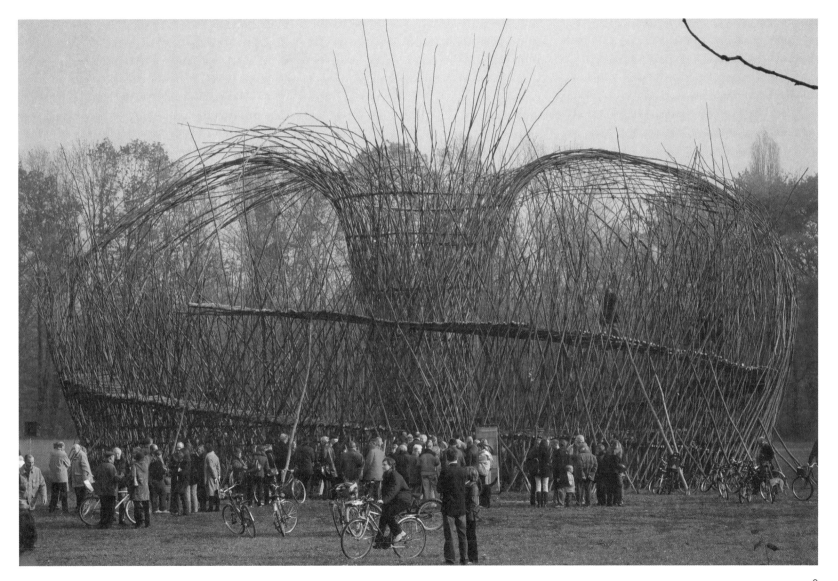

ART, ARCHITECTURE, AND NATURE: A NEW KIND OF ENVIRONMENTAL IMPACT

by Francesca Tatarella

We explored the concept of "natural architecture" in a book titled just that. It was published in 2006.

That first volume collected the work of artists and architects who challenged themselves to work with low-cost and largely natural materials found on-site, as well as with elementary technology. Many employed only their own hands and a few simple tools to build their creations.

These pavilions, observatories, and shelters are site-specific installations that bring visitors into deeper contact with nature so that they can experience its sights, sounds, and smells. As works of art, they rely on a new concept of beauty, prizing the disordered and the wild over more traditional formality.

Nature has often been banished from populated environments, where, if it appears at all, it is often only present in the form of carefully groomed gardens and parks. These installations give people a chance to experience nature in those settings and others. And they speak to a different concept of time, as well. They are by definition temporary; while visiting them, we cannot help but be reminded that sooner or later, the branches and leaves that form their outer shells will rot and be absorbed back into the landscape, just as stones will fall from foundations and, over the ages, be worn away until they are just pebbles.

This second volume of *Natural Architecture* includes more of the intriguing work of Patrick Dougherty, who weaves branches together, and the work of Japan-trained architect Ueno Masao, who creates sculptural objects on a grand scale, relying only on the use of his hands and his knowledge of his chosen material, bamboo. Alfio Bonanno creates enormous pods by weaving together different types of branches that wash up on the shores of Lake Simcoe in Ontario, making his work a reading of a specific environment.

These sculptures become part of the locations where they stand. They establish a link between man and nature and simultaneously help to create a new vision of those places.

Like the work in the first volume of *Natural Architecture*, this diverse collection showcases an array of artists and architects who strive to engage different dynamics that involve all aspects of human life and our relationship to the spaces in which we live.

The architect's first step in this task is to bring the viewer into the landscape—whether it's a natural or an urban environment—by providing a unique observation point. The viewer is

inserted into a new and unusual situation and has an opportunity to reflect on the relevant dynamics and aspects of society the work speaks to.

Many of these artists are concerned with social issues related to community life. This may mean they supply needed residential or communal spaces. Or their work may reawaken environmental awareness of a particular area, drawing attention to everyday actions that undermine delicate ecological balances.

Broadly speaking, the themes of estrangement and surprise underlie most of these projects. In other words, these installations cause disorientation, either spatially or culturally, and then lead the viewer directly and specifically to a goal. That goal is often as simple as seeing the world from a new perspective.

In the case of the Starn twins and their unusual installations in New York, Venice, and Rome, that change in perspective is paired with a significant change in altitude. Visitors who clamber atop a fragile-looking structure made of a material—bamboo—that isn't normally considered very solid experience mixed feelings of fear and attraction. The small rooms and resting areas that the Starn brothers create at varying heights actually force visitors to stop and survey the surrounding landscape from above. Their views of the environment cannot help but be changed by the resulting simultaneous wonder and fear. Porky Hefer, too, invites his audience to reach new heights—if in a more comforting manner—by building human-sized nests—true tree houses—at various levels.

Some small works of architecture invite guests to rest as they look around them. In Tatton Park in Great Britain, Heather and Ivan Morison created a shelter that is both an observatory and a performance space.

Many of the observation points created by Rintala Eggertsson, Paolo Mestriner, Massimiliano Spadoni, and Studio Weave are located on hilltops, offering views of the surrounding environment. These often incorporate elements from observatories and shelters, such as hearths, where microcommunities can form around fires.

Today, thoughts about landscape are intrinsically tied to environmental awareness. Art therefore serves as a useful tool that can stimulate people to care for the environment in creative ways.

Daniel McCormick uses his work as an artist to transform a typically anthropocentric perspective into a gaze that takes in the environment and the landscape. Using techniques borrowed from natural engineering while maintaining a modern sense of aesthetics, McCormick weaves together red willow branches to create a net that staves off the erosion of a riverbank.

Ants of the Prairie does much the same with its *Bat Tower*, a pillar designed as a vertical cave to house bats and encourage them to reproduce. This small structure provides a new perspective on the landscape, but it also directly interacts with its surroundings: bats play a key role in the ecosystem as pest controllers and pollinators, and *Bat Tower* works as a functioning catalyst for their survival.

Mexican artist Yolanda Gutiérrez also creates work intended for use by animal species; in the Mexico City area she created an installation of woven reeds and sedges that serves as a shelter for migrating birds.

This new volume expands on the idea of natural architecture further by including projects in public spaces in metropolitan areas.

Some of these art installations are tools that help people interact with their locations. They not only reestablish social relationships that local residents have with each other, but also create or strengthen the relationships between those residents and the urban spaces around them that have deteriorated or been abandoned.

With his *Cityscape*, a 180-meter-high wooden sculpture in a city square in Brussels, Arne Quinze attracts locals to an area that had been all but deserted and invites them to interact outside of their comfort zones. *Cityscape*'s large roof also provides shelter; light filters through the planks of wood, fostering a warm, communal space. Indeed, the welcoming and reassuring environment created by the material stimulates interaction by inspiring conversation and shared experiences. This previously empty public square is once again filled with life, acting as a social space.

Marco Casagrande's installation, *Bug Dome*, occupies an empty lot where a building was demolished, in a spot halfway between Shenzhen City Hall and a camp occupied by itinerant workers. *Bug Dome* is a bamboo structure that serves as shelter, stage, and earth; the 2009 Shenzhen-Hong Kong Biennale of Urbanism and Architecture used it as a site for concerts, poetry readings, and discussions. When the Biennale was over, it became a lounge and meeting space where workers from the nearby camp could gather.

Another concept new to this volume is natural architecture that is used in response to emergencies or for other social needs. In some of these situations, there is a need for small buildings that can be easily replicated. These buildings employ techniques that architects can teach to the members of local communities so that they can build on-site without professional assistance.

At the request of the residents of Manabí, Ecuador, Al Borde Arquitectos used this system to design a school that would be inexpensive to build and would integrate with the

environment by fitting into the land's topography and through its use of traditional construction materials. The goal was for local residents to participate in building the school and learn the construction method along the way. Once a community makes the system its own, architects are no longer necessary. At a later date, the residents of Manabí expanded the building to fit their needs.

Similarly, RAI Studio in Tehran responded to potential housing emergencies (such as earthquakes) with the production of small, dome-shaped shelters that are extremely sturdy. The buildings were made from bamboo poles and covered with rice straw and mud so that they provide an appropriate interior temperature both in summer and in winter. In response to the limitations of the situation, these architects conceived of small structures without fixed foundations—they can easily be transported from one place to another. These small buildings use basic techniques, and three nonprofessionals can build one quickly with minimal costs.

These new concepts in natural architecture both expand the field in general—which helps it to be explored in depth—and open it up to new creators—and new viewers—with diverse backgrounds.

nARCHITECTS

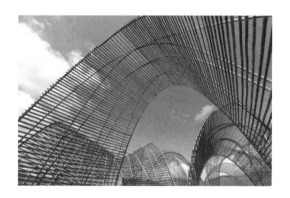

"Our approach to context is nuanced and agile—
sensitive to opportunities and irreverent to cliches.
We approach environmental questions as both
a technical and cultural issue. In short, we aim for
simple designs that produce a richness and flexibility
of experience, with an economy of conceptual
and material means."
—nA

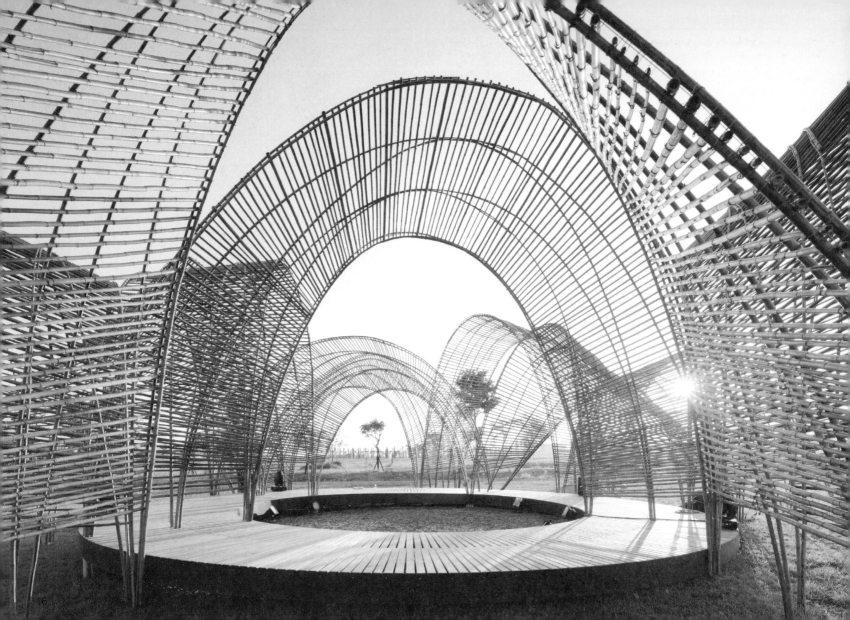

Forest Pavilion (Y Lu Duqai A Luma)
Guangfu, Hualien, Taiwan, 2011
Green bamboo, steel, wood,
984 square feet (300 square meters)

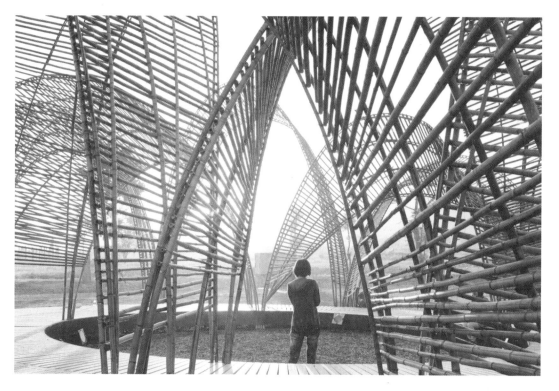

Completed in May 2011, *Forest Pavilion* is a bamboo pavilion inside the Da Nong Da Fu Forest and Eco-park in the province of Hualien, Taiwan. It serves as a visitors' center and performance space for open-air entertainment. The pavilion was officially opened on May 22, 2011, by Taiwan's president, Ma Ying-jeou, to inaugurate the Masadi Art Festival.

 Forest Pavilion is built on a circular wooden base. Composed of bamboo poles, it's 60 feet (18 meters) in diameter and 22 feet (7 meters) high. The bamboo was harvested just before construction, as it needed to be flexible and elastic for the vaults around the circular base to be created. nARCHITECTS used the same material and construction technique in its *Canopy* installation at New York's PS1 MoMA outpost in 2004.

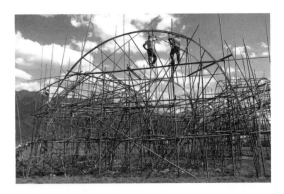

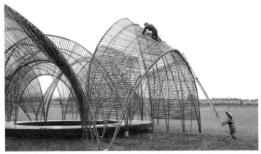

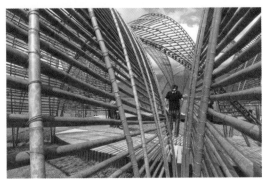

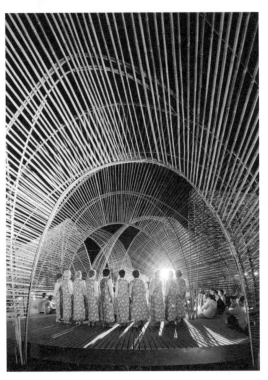

The resulting structure appears to grow out of the ground. The eleven bamboo vaults are arranged in two concentric rings around an open space in the center. The design is meant to recall the rings of a tree trunk. The various shapes and forms of the vaults reflect the harmony of nature and the forest where the installation stands.

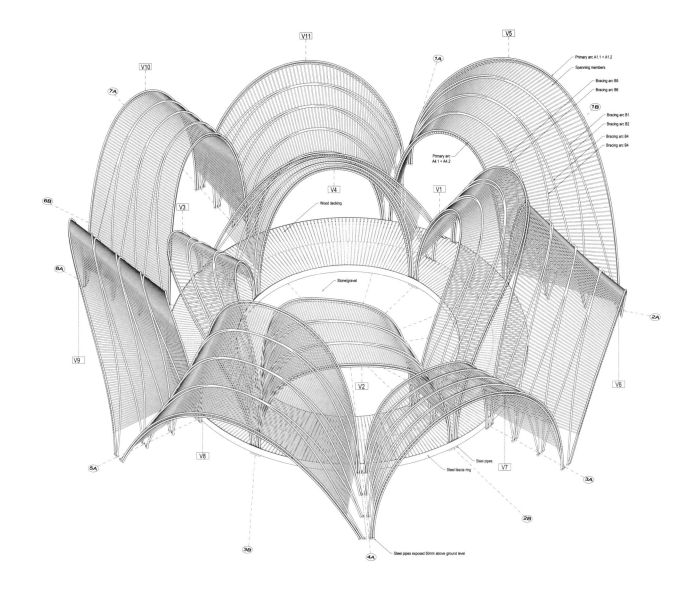

V11

V5

V10

1A

7A

Primary arc A1.1 + A1.2
Spanning members
Bracing arc B5
Bracing arc B6

1B

Bracing arc B1
Bracing arc B2
Bracing arc B4
Bracing arc B4

V4

V1

Primary arc
A4.1 + A4.2

6B

V3

Wood decking

6A

Stone/gravel

2A

V9

V6

V2

V8

Steel pipes

V7

Steel fascia ring

5A

3A

3B

2B

4A Steel pipes exposed 50mm above ground level

19

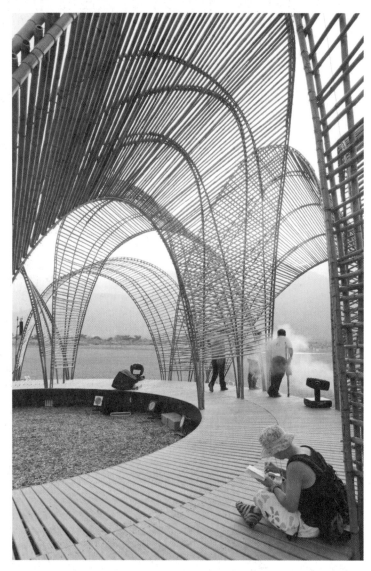

nARCHITECTS aimed to create an installation that would become a landmark in the area and that would simultaneously provide a sense of security and intimacy. *Forest Pavilion* is closely linked to the surrounding area; light and delicate, it is minimal almost to the point of being diaphanous. At night it is lit up—a beacon in the forest that can be seen throughout the peaceful valley.

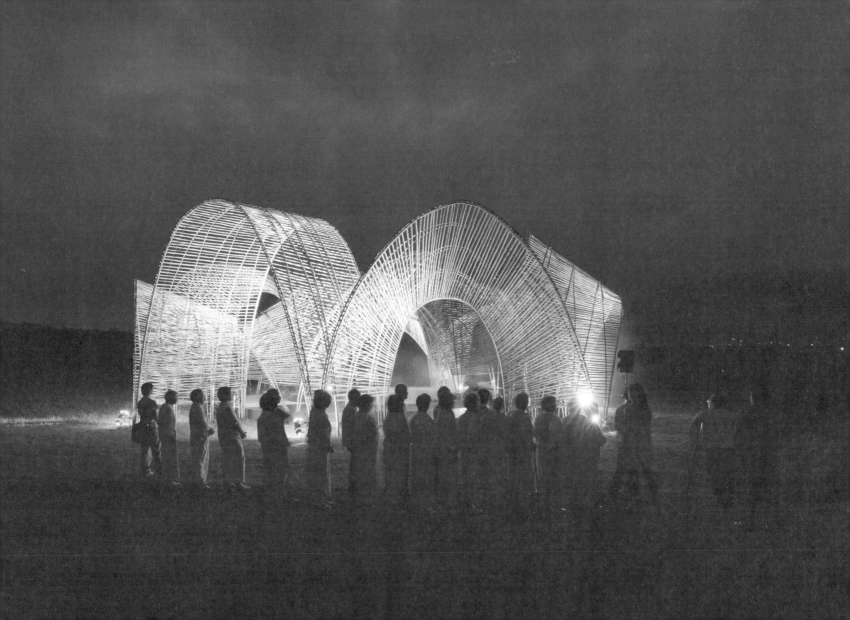

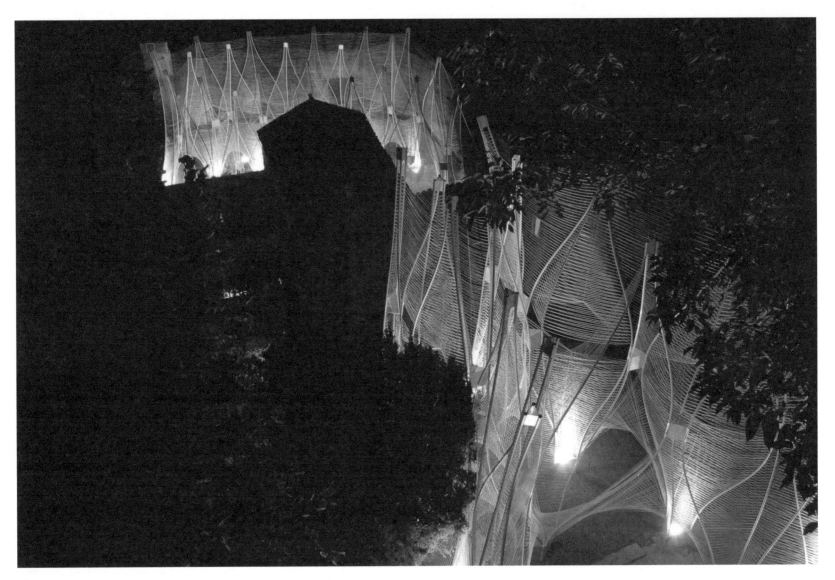

Windshape
Lacoste, France, July 2006
Plastic pipes, approximately 30 miles (50 kilometers)
of polypropylene string, aluminum hooks

Windshape is an ephemeral installation
commissioned by the Savannah College
of Art and Design for its campus in Provence.
It was completed in July 2006. Constructed
by nARCHITECTS and a team of students
over the course of five weeks, *Windshape*
was intended to serve as a gathering place
and a venue for concerts, shows, exhibits,
and other events.

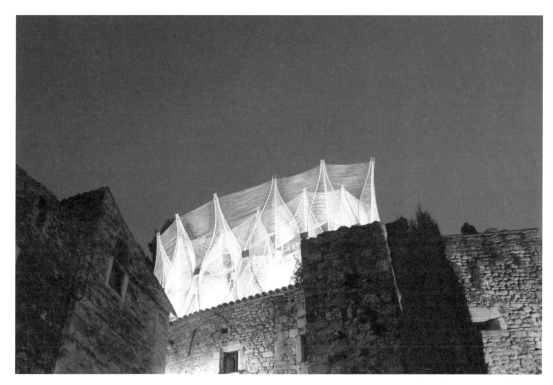

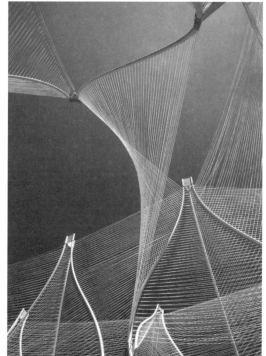

Windshape is composed of several pavilions that stand as tall as 57 feet (8 meters) high. Rising from the walls of an ancient building on a hill in Lacoste, the pavilions move gently in the Provençal wind. The structure is made of plastic pipes and more than 30 miles (50 kilometers) of white polypropylene string. The strings are woven in an alternating dense and open pattern to form closed surfaces, windows that look out over the landscape, doors, and seating areas.

The strings that comprise the structure are hung with varying degrees of tension, so it sways in the wind, moving rhythmically in response to this natural force. When the wind is very strong, the entire installation moves dramatically, and the wind creates a hissing sound similar to that of a jump rope in motion. The shape of the installation also changes in response to the strength of the wind. At night the illuminated pavilions serve as a reference point in the landscape—indeed, they are visible from as far as the village of Bonnieux, three miles (five kilometers) away.

Supple + structural network registers wind

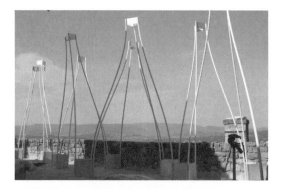

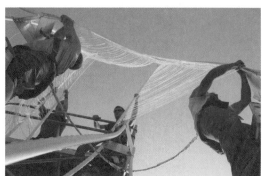

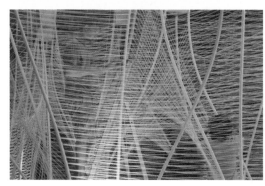

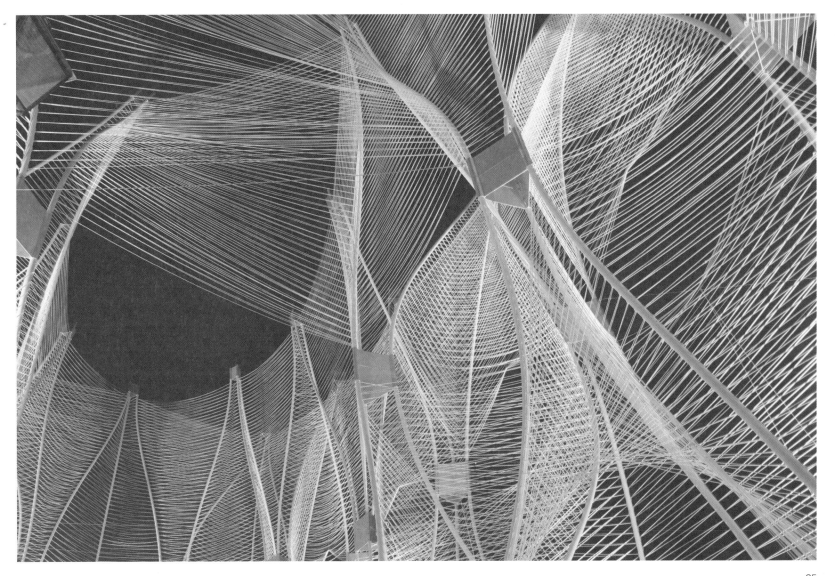

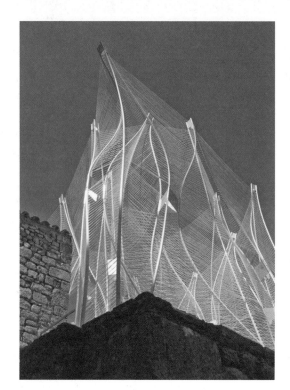
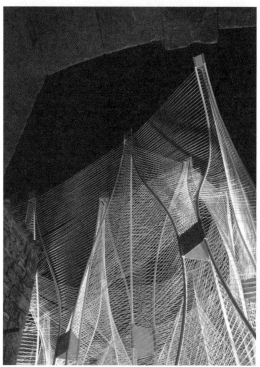

The design for *Windshape* was developed by Savannah College of Art and Design students themselves, allowing them to play with the idea of a structure that responds to natural stimuli and forces.

"Rather than simply sheltering us from the elements, buildings of the future could connect inhabitants to their environment, reminding them of its strength and beauty."
—nA

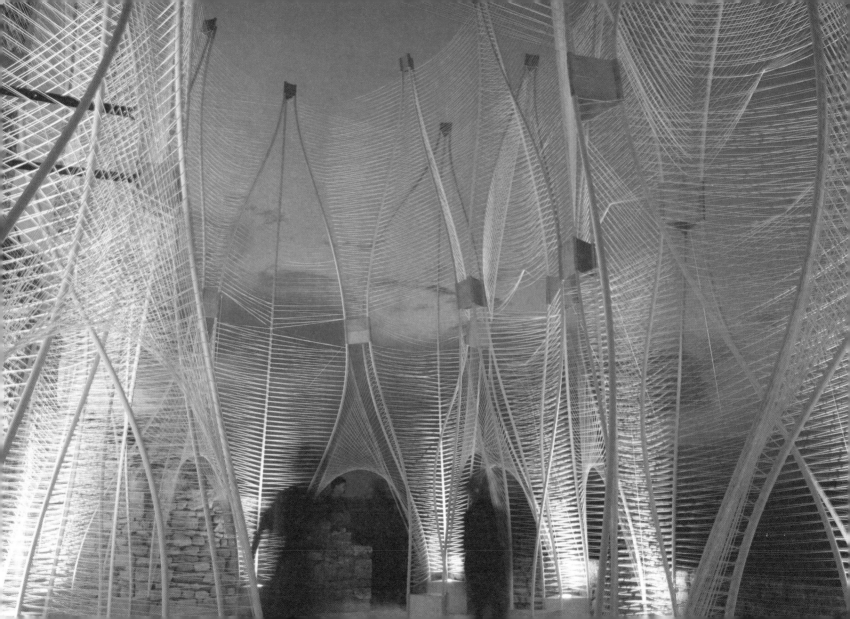

KADARIK TÜÜR ARHITEKTID

"We tried to avoid a concrete narrative in this solution. The stage is an abstraction, which sets the mood."
—KTA

"Noor Eesti" scenery
Rakvere Summer Theater, Tallinn, Estonia, 2011

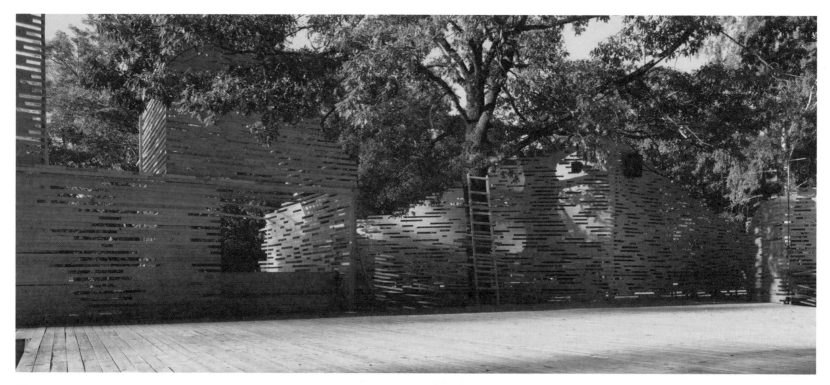

Kadarik Tüür Arhitektid's outdoor theater was created for a series of twelve plays at the Rakvere Summer Theater. The goal was to build an intimate, closed, and comfortable space that would immediately create an emotional connection between the audience and the actors. The architecture framed the landscape so that the park, the trees, and the pond become an integral part of the stage itself.

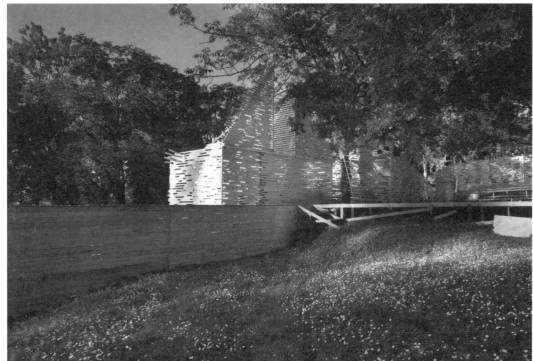

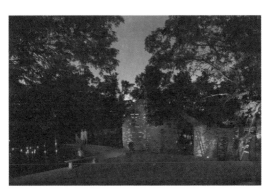

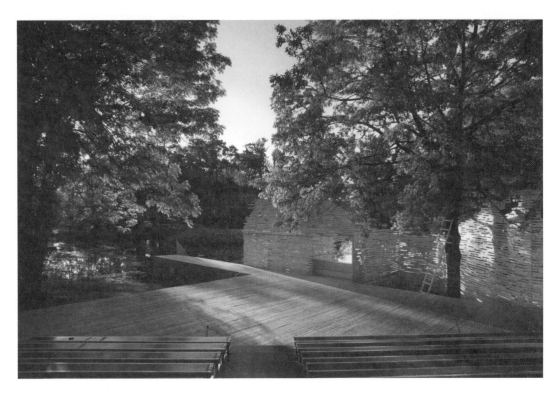

The wings of the stage, which almost seem to meld with the landscape, were made with 2-by-2-inch (50-by-50-millimeter) wooden planks, which were designed to achieve a visual texture that draws the audience and the performers together.

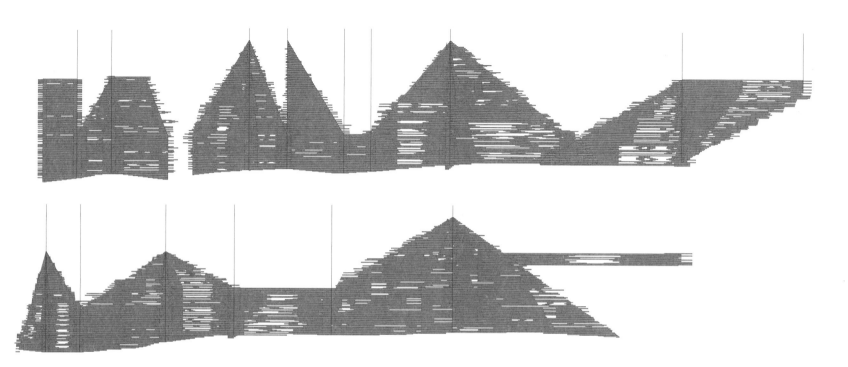

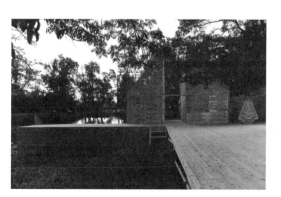
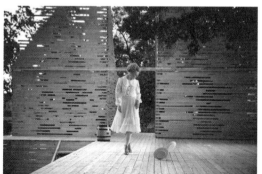

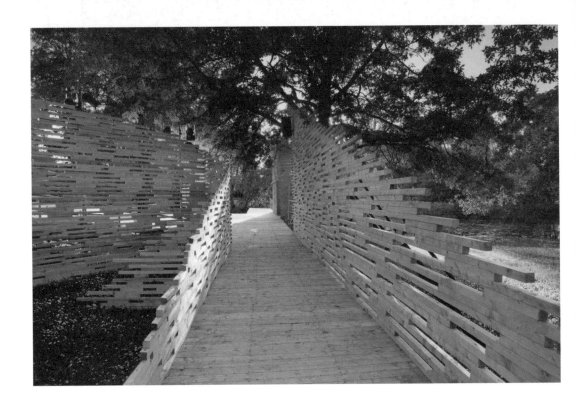

The theater sat up to 420 people, and the stage was 3,000 square feet (280 square meters). After the plays were performed, the entire structure—made solely of wood—was dismantled so that it could be recycled to build new theater structures.

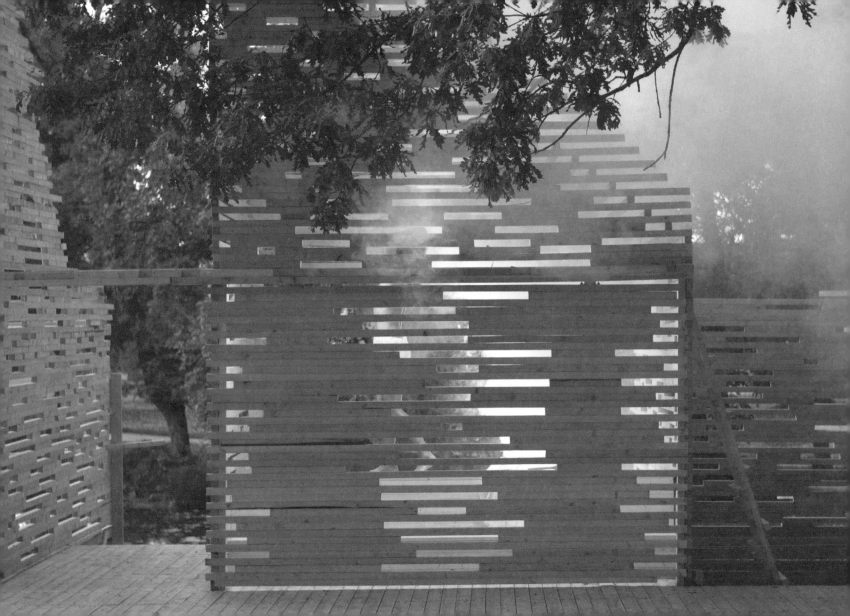

HEATHER & IVAN MORISON

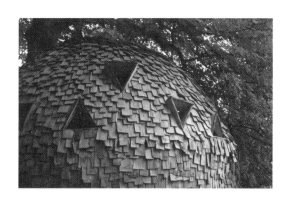

"The Morisons' work really pushes your imagination. At first you think you've come across some cozy yurt-ish new age traveler structure, but the more you dwell on it the less cozy it becomes. It's all about a fantasy of post-apocalyptic survivalism, with all the misanthropy and horror that implies."
—William Shaw, Best of 2008, RSA Arts & Ecology

I am so sorry. Goodbye (Escape Vehicle number 4)
Commissioned for the Tatton Park Biennial, Tatton Park, United Kingdom, 2008

"I am so sorry. Goodbye (Escape Vehicle number 4) comprises two intersecting geodesic spheres, hand-built from wood harvested from naturally fallen trees in Tatton Park, and functions as shelter, observatory, and performance space, where visitors are served tea."
—Paul Griffiths, Tatton Park Biennial, *Shakkei* 15, no. 3, 2008.

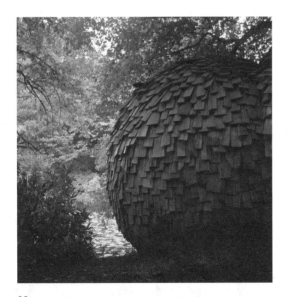
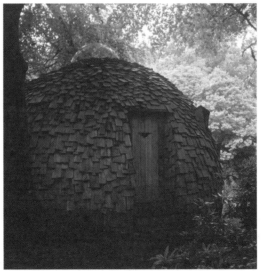

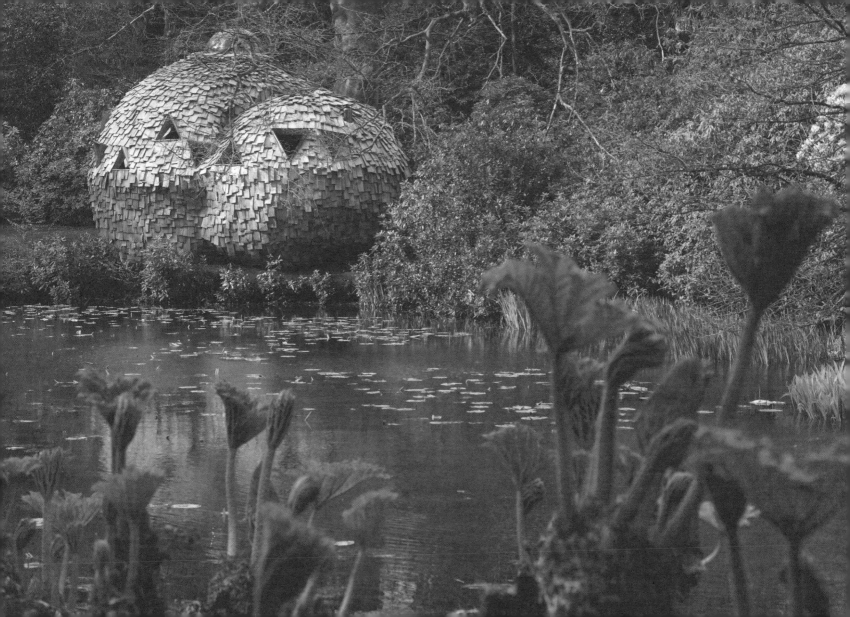

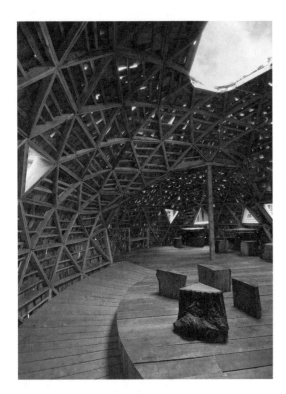
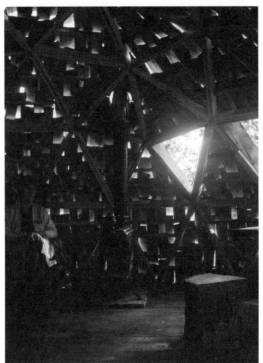

"*The conjoined domes of* I am so sorry. Goodbye *are inhabited by a guardian whose task is to keep the stove lit, water boiled, and visitors supplied with hibiscus tea. The guardian has the vocabulary of the words: I, am, so, sorry,and goodbye. These words were first conveyed to us whilst staying in an old upmarket hotel on Alexandria's corniche. Late one night I received a call in which the only words that were said, by the slow doleful male foreign voice, were 'I am so sorry sir…I am so sorry sir…Goodbye sir.' After putting the phone down I felt witness to something I didn't fully understand, but felt that we had been given the task to pass on this cryptic message.*"
—Ivan Morison, 2008

The structure's two conjoined geodesic domes were made with found materials; the artists collected and reused wood found at the installation site. The geodesic dome is the only man-made structure that is stronger the bigger it gets: the artists viewed the project as an opportunity to insert something perfect within a natural environment. The exterior is covered in wooden shingles of various sizes, layered on top of one another to form a sort of exoskeleton. Taken as a whole, the installation evokes that of a natural element at one with its location.

How to Survive the Coming Bad Years
Commissioned by Meadow Arts for the exhibit Give Me Shelter, Attingham Park, Shropshire, United Kingdom, 2008
Soil, straw, water, wood, lime, ceramic pipes

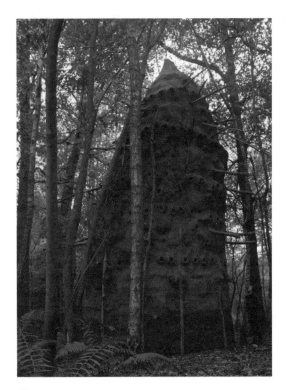

"In an ancient woodland at the core of Attingham's vast 4,000-acre land, an immense clay structure rises through the trees like an oversized Dalek. Both alien and primeval, How to Survive the Coming Bad Years *is inspired by traditional rookeries found throughout the Middle East. Ivan and Heather Morison's huge-lime covered cob sculpture suggests the vestige of an otherworldly civilization or perhaps a postapocalyptic future."*
—Meadow Arts, Give Me Shelter.

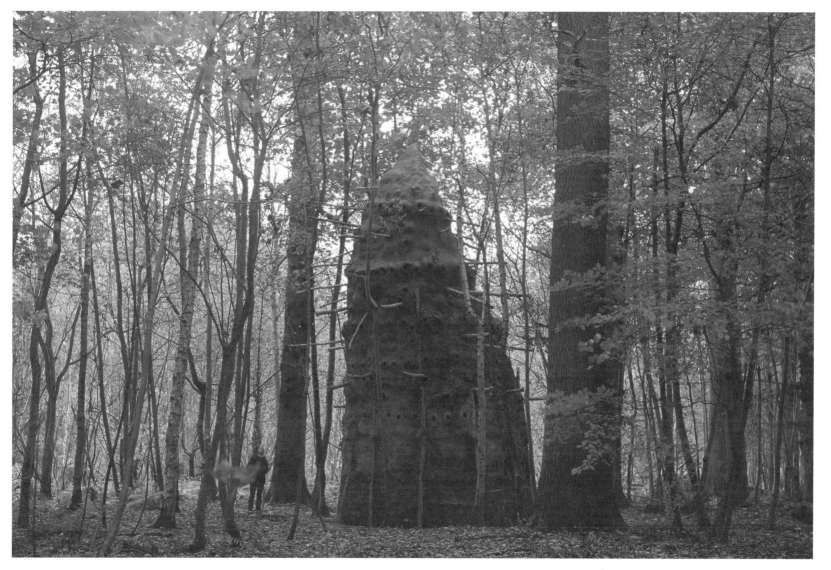

PORKY HEFER DESIGN

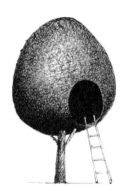

"Biomimicry (from bios, meaning life, and mimesis, meaning to imitate) is an ancient concept recently returning to scientific thought that examines nature, its models, systems, processes, and elements— and emulates or takes inspiration from them to solve human problems sustainably. Nature builds to shape, because shape is cheap and material is expensive. By studying the shapes of nature's strategies and how they are built, biomimicry can help you minimize the amount you spend on materials while maximizing the effectiveness of patterns and forms to achieve desired functions."
—PH

Weaver's nest
Series
South Africa

"With all the talk about sustainable architecture and about lessening your footprint, I wanted to explore what happens when you copy most birds and suspend rather than erect. I also wanted to explore the idea of using local, sustainable, natural materials that could be found within a small radius of the 'construction site' rather than traveling great distances. I work with various weavers in different disciplines, tapping into the different local crafts and techniques readily available in South Africa. I was particularly interested in the building styles of the members of the ploceidae, or weaver bird family, who craft beautifully artistic and humble dwellings that differ according to the vegetation they are built in, the vegetation they are built with, and the predators that are in the area."
—PH

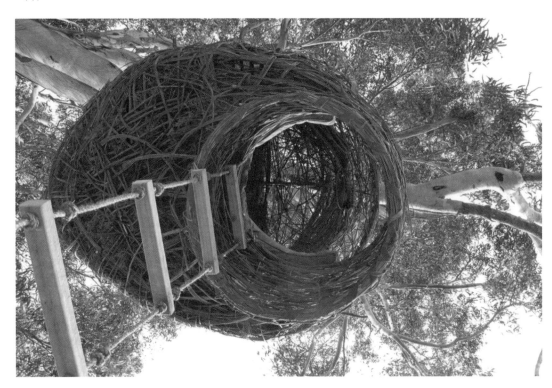

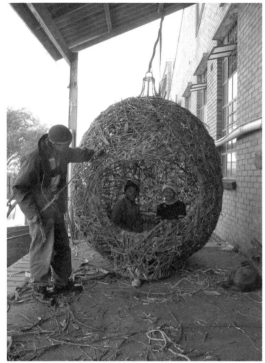
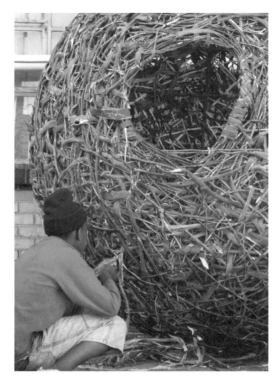
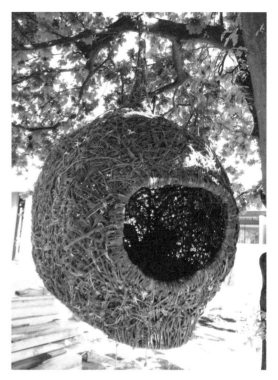

Weaver's Nest—Mark 2
Tokara Farm, Stellenbosch, South Africa
Steel structure covered in willow branches
8 x 6.5 x 5.5 feet (2.5 x 2 x 1.7 meters)

"Some nests are made with a steel inner structure and then woven with saplings and the bark of various invasive plant species. Others are made entirely from Kubu cane like the baskets for hot air balloons are. The nests are intended to be suspended from trees and accessed by various types of ladders/stairs. Most of the nests are around two meters by two meters and can accommodate three to four adults and a couple of eggs. The nests were originally intended as hides for game reserves, so people could blend into the environment without being seen by the wildlife."
—PH

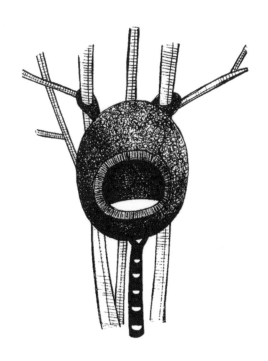

Bridle Road Nest
Cape Town, South Africa
Kubu cane and wood 6.5 x 6.25 x 6.25 feet
(2 x 1.9 x 1.9 meters)

At this site, some of Hefer's nests hang from trees, with the majority of their weight resting on supports that also act as ladders. Other nests are true tree houses—fully integrated into the trees.

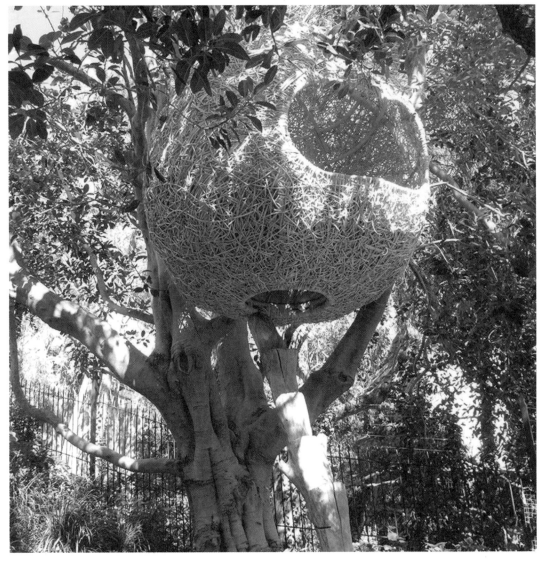

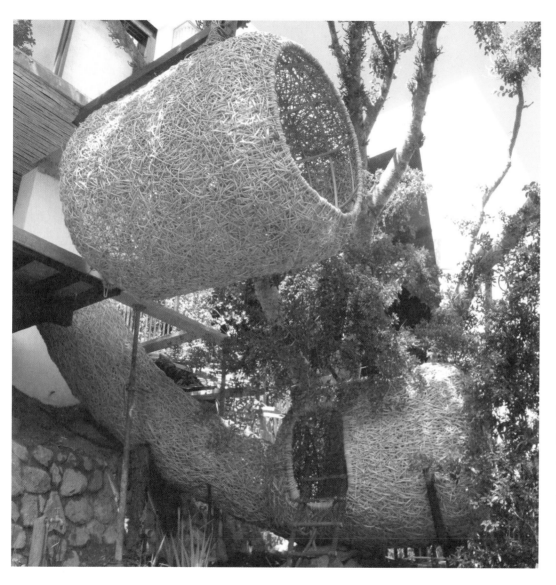

Nettleton Road Nest
Cape Town, South Africa
Kubu cane

This structure consists of two "inhabitable nests" that are accessed from above via a woven slide. Each nest is designed, conceived, and created specifically for the installation site and in response to the client's needs. Each is a different size and has different characteristics.

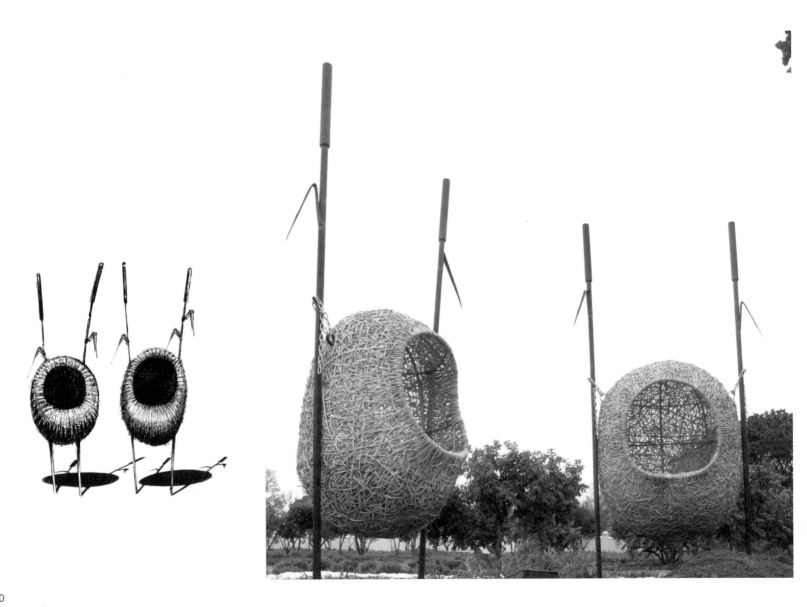

Weaver's Nest in Babylonstoren
South Africa
Kubu cane 5.9 x 6.5 feet (1.8 x 2 meters)

The nests are made using the construction methods of weaver birds. Some of the inhabitable nests are hung on two poles that look like reeds.

"I have explored different materials, from Port Jackson alien vegetation to Kubu cane to waste materials, looking for the most sustainable and effective solution. I collaborate with experts in the various weaving techniques to achieve what I dream."
—PH

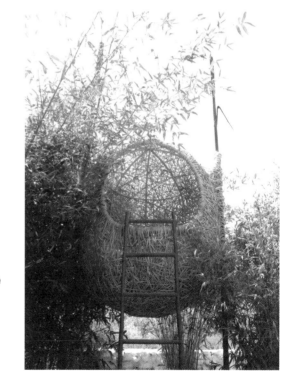

PATKAU ARCHITECTS

"These are delicate and 'alive' structures. They move gently in the wind, creaking and swaying to and fro at various frequencies, floating precariously on the surface of the frozen river."
—PA

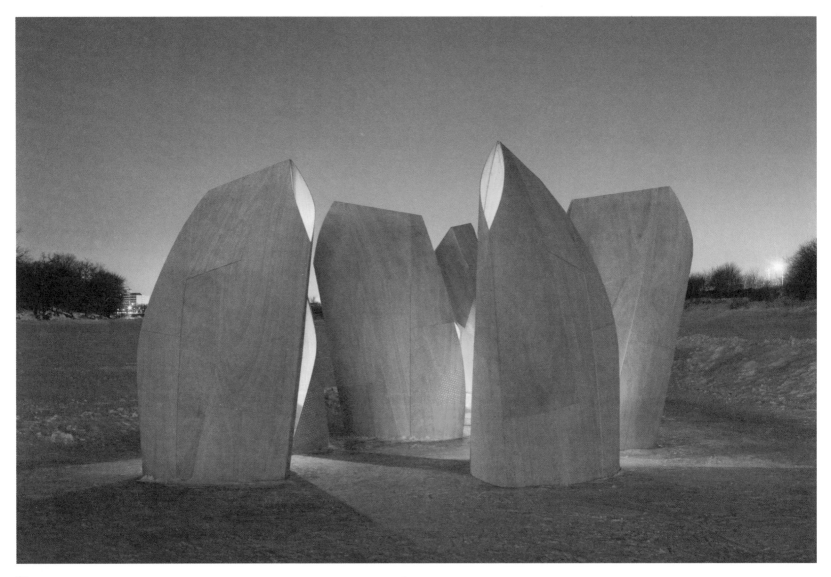

Winnipeg Skating Shelters

Winnipeg, Manitoba, Canada, 2010–2011
5.5 square feet (1.65 meters) per shelter x 6 shelters
spread out over roughly 107 square feet
(33 square meters)

"Our proposal consists of a cluster of intimate shelters, each accommodating only a few people at a time. They are grouped in a small 'village.' They stand with their backs to the wind like buffalo, seeming to have life and purpose as they huddle together, shielding each other from the elements."
—PA

The Red and the Assiniboine Rivers meet in the center of Winnipeg, where the winter temperatures can drop as low as –20˚F to –40˚F (–30˚C to –40˚C). The city's frozen rivers are crisscrossed by miles of skating and cross-country skiing trails. These shelters by Canadian firm Patkau Architects were created along the trails. They serve as temporary shelters, where people can take refuge from the cold winds along the river.

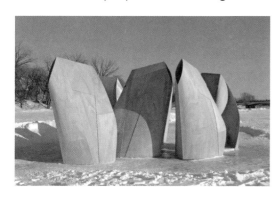

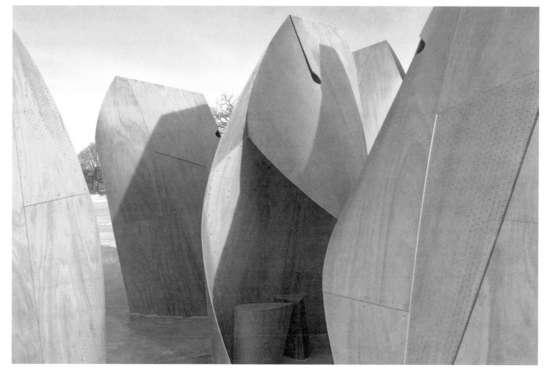

The shelters were built out of very thin and flexible strips of plywood. These strips consist of two layers that are each 3/16 of an inch (5 millimeters) thick. They form both the structures themselves and the exterior skin. Because the plywood strips are so malleable and flexible, these small buildings inhabit the space in an unusual way.

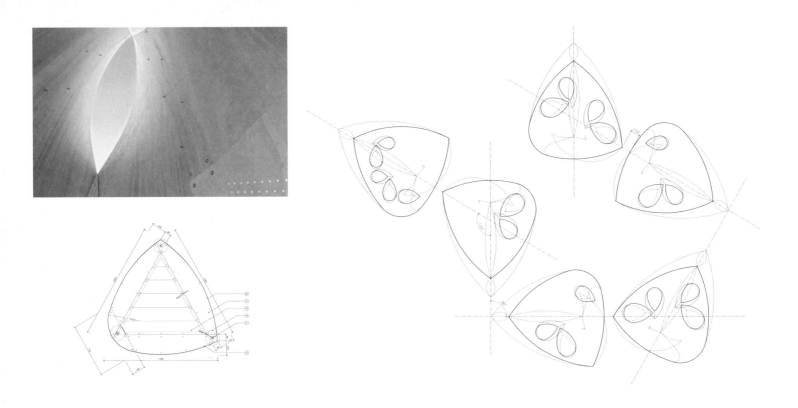

At first glance, the shelters may appear to be positioned at random, but they were actually very consciously arranged. The first two were positioned to form an entrance to the group and rotated 120 degrees. Then the remaining huts were positioned at 90 degrees from one another. The empty space between the shelters helps lend identity and strength to the project as a whole.

Before construction, several prototypes were made to determine how the material would react as it was deformed and flexed; the most fragile points in the plywood strips were identified, and cuts were made at those points to relieve stress. This process of stress/deforming and releasing gives the shelters their shape.

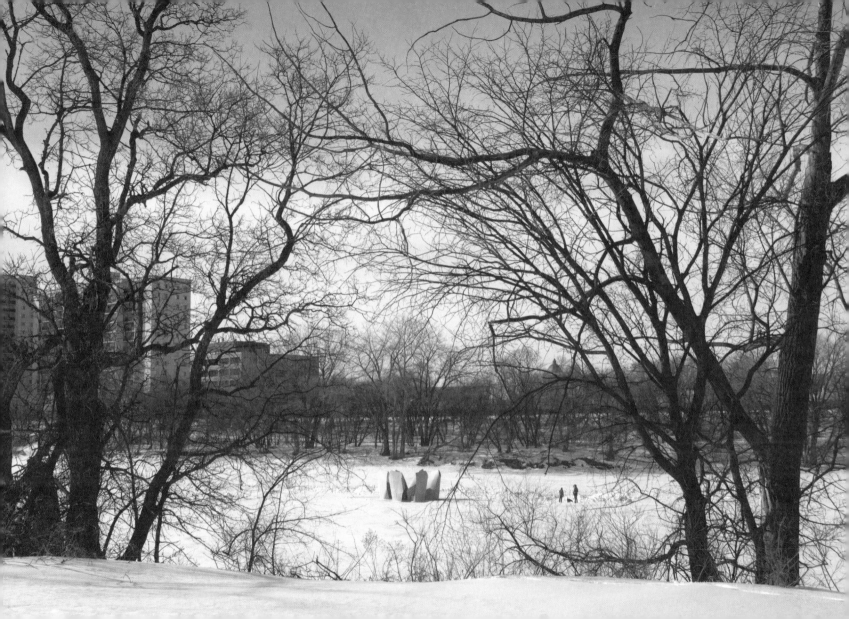

ANTS OF THE PRAIRIE

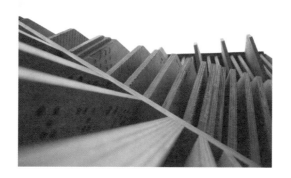

"Ants live and work in the vast and seemingly indefinable prairie. Their actions, however minute, contribute to the shaping of unfamiliar territories. Ants thrive on conflicting tendencies, acting both as individuals and as part of a collective super-organism."
—AOTP

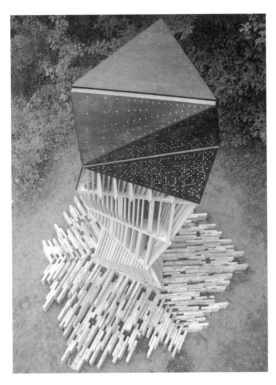

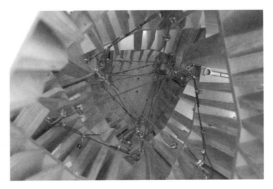

Bat Tower
Griffis Sculpture Park, East Otto, New York, 2010
Project manager and work supervisor: Joyce Hwang—Ants of the Prairie
Commissioned by the New York State Council on the Arts (NYSCA), in cooperation with the University at Buffalo, Department of Architecture and Planning

Ants of the Prairie is an architecture and research practice that aims to develop creative approaches to dealing with both the "pleasures and horrors" of the contemporary ecology systems that we inhabit.

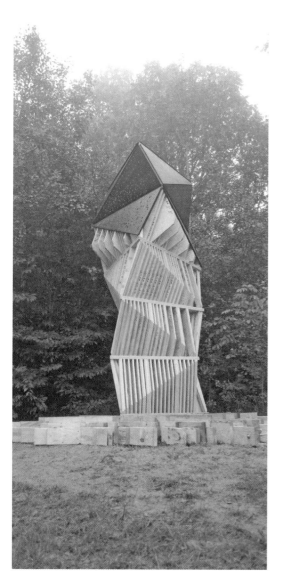

Bat Tower was the first prototype to be built from Joyce Hwang's *Pest Architecture* series. The aim of the project was to create an element that, in addition to tackling an ecological issue, contributes to promoting awareness of the importance of bats in western New York State's ecosystem. Acting as natural pest-controllers and pollinators, bats have traditionally played a key role in the region's environment (as they do across the globe). However, bats are often considered a harmful species that should be eliminated and exterminated. In order to give this misunderstood mammal greater visibility, the *Bat Tower* goes beyond the usual structures commonly sold as bat houses. Indeed, rather than disappearing into the landscape and being camouflaged by the surrounding environment, this tower stands tall and is clearly visible in the area.

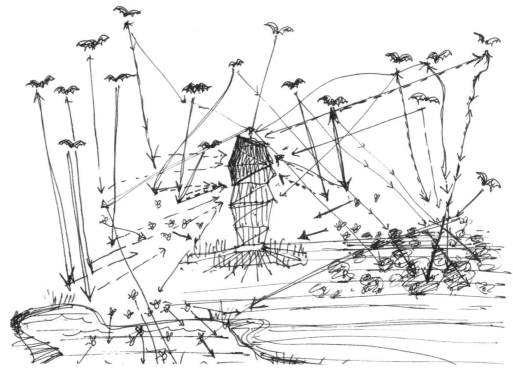

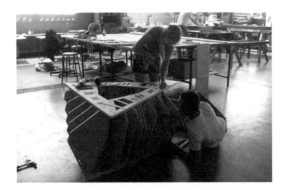

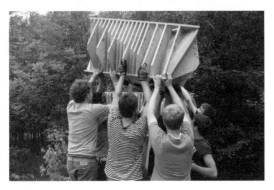
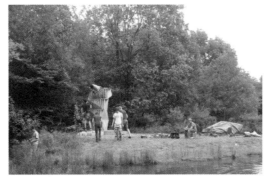
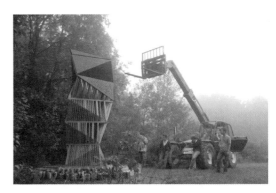

Bat Tower is a vertical cave designed to attract bats and encourage their repopulation in the area. The tower is a new element introduced into the landscape—it is both a catalyst and a point of reference. The installation is near a pond, so the area teems with mosquitoes and other insects that bats eat. Plants that attract bats, such as oregano and chives, were planted around the base of the tower. The tower is ribbed and has built-in "landing pads," all with an eye to encouraging bats to enter.

Because there are openings in both the vertical and the horizontal spaces and the structure is hollow, bats can easily enter the tower and grip the ceiling. Because bats require a warm environment for nesting, the roof of the structure is covered with dark wood panels that absorb the heat of the sun.

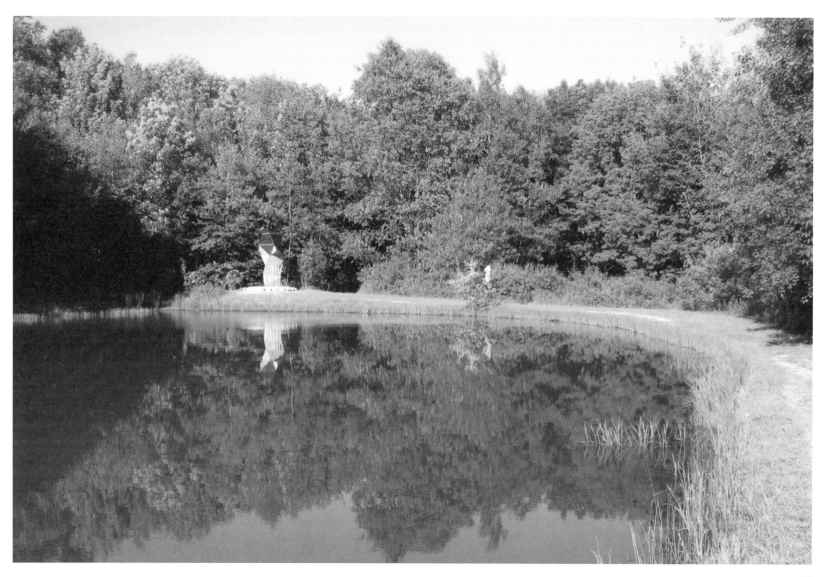

YOLANDA GUTIÉRREZ

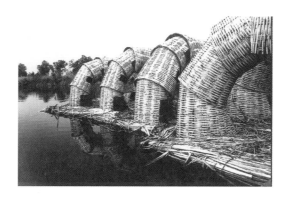

The work of Yolanda Gutiérrez uses art to glorify
nature as the source of life, the origin and reflection
of our very essence. Inspired by myths and symbols
from various cultures, she creates poetic images
out of natural materials.

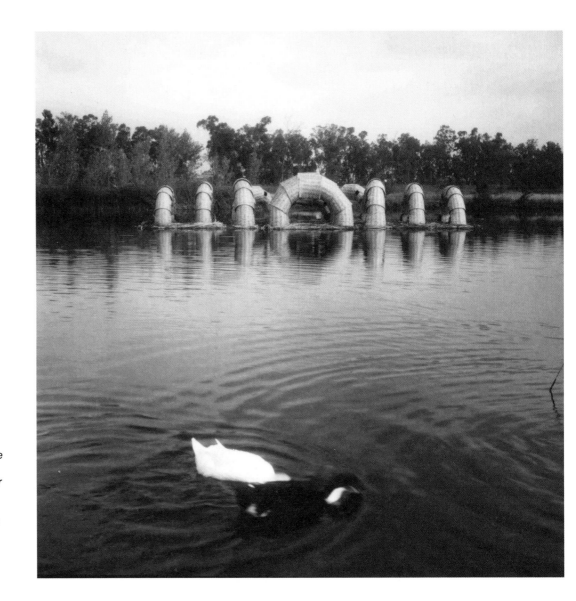

"The intention was to create a shelter for migrating birds, a safe place to encourage reproduction in the middle of one of the last protected natural areas in the Mexico City metropolitan area, which is under constant risk of water contamination. We made 'pilot nests' first in order to observe how the birds responded to the materials chosen for construction and to check the best size for the elements used for nesting and reproduction. I wanted to create a new kind of architecture just for birds."
—YG

Sanctuary (Santuario)
Ecological Sporting Center of
Cuemanco, Xochimilco, Mexico, 1994
Woven reeds and sedges
In cooperation with Mexico's National Fund
for Culture and the Arts

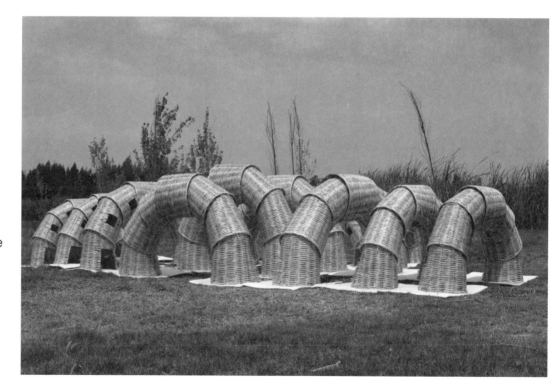

This installation is an environmental sculpture
designed to encourage migrating birds
to nest in the Mexico City area. The artist
worked with biologists and ecologists
to create the piece. It is not a mere work of
art, but a scientific-ecological project as
well. Since its construction, several different
species of aquatic birds have nested in
the installation.

STRIJDOM
VAN DER MERWE

"My working method is to walk in the forest and to find a space that will be best for the sculpture. It must be a place that complements both nature and sculpture."
—SVDM

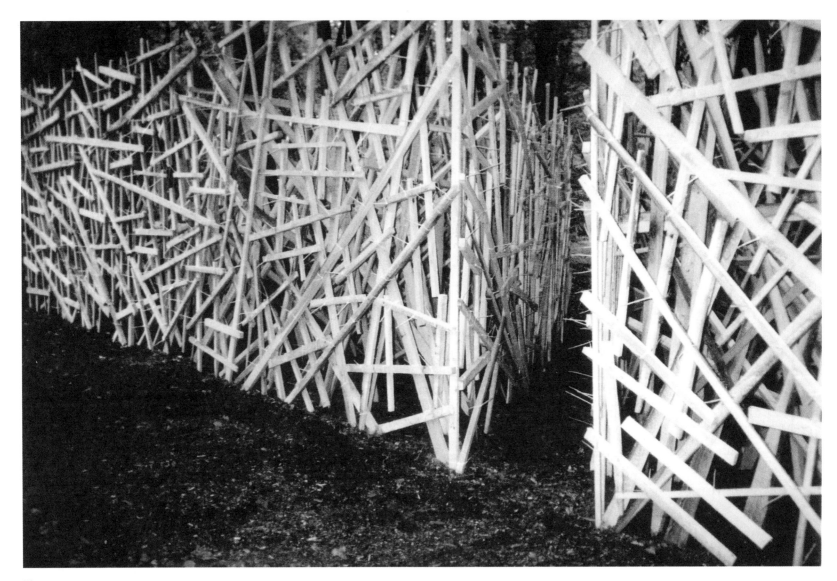

Deconstruction Reconstruction
La Fête de Mai, Mozet-Gesves, Belgium, 2004

"*Trees have been cut down and taken to a sawmill. There they are 'deconstructed' into material that can be used for various purposes. I have collected off-cut wood from the sawmill that is not being used anymore to 'reconstruct' a structure.*"
—SVDM

Deconstruction Reconstruction is a rectangular structure that is 65 by 20 feet (20 by 6 meters) at its base and about 6.5 feet (2 meters) tall. A narrow path cuts through its middle, allowing visitors to walk through the sculpture and experience it from the inside.

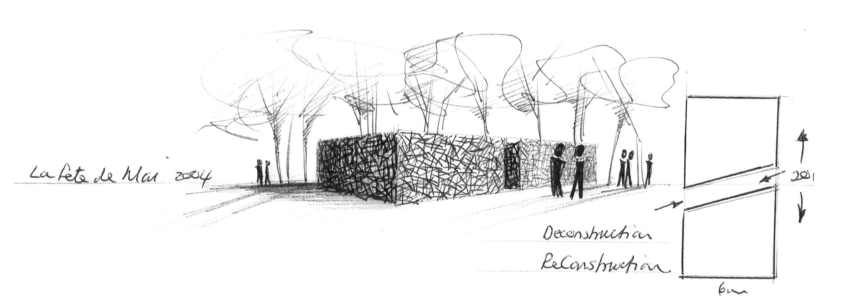

Sanctuary of a thousand sticks
Luleå Summer Biennial, Norrbottens Museum of Art, Luleå, Sweden, 2003

Sanctuary of a thousand sticks is a circular sculpture made of sawmill waste. The pieces of wood are joined together using steel cables to create a solid three-dimensional structure six feet (two meters) tall.

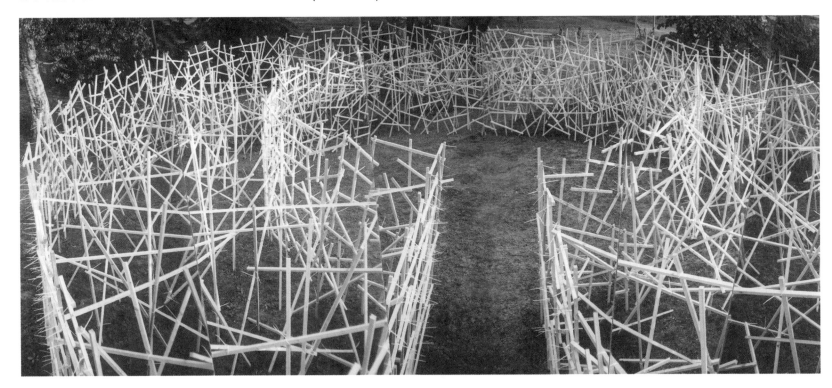

"It's a sculpture that provides you with the basic needs within nature. A place to feel safe where you are comfortable, your own sanctuary."
—SVDM

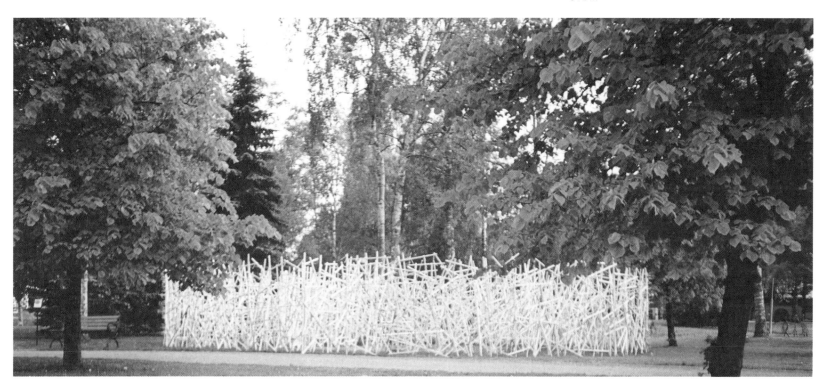

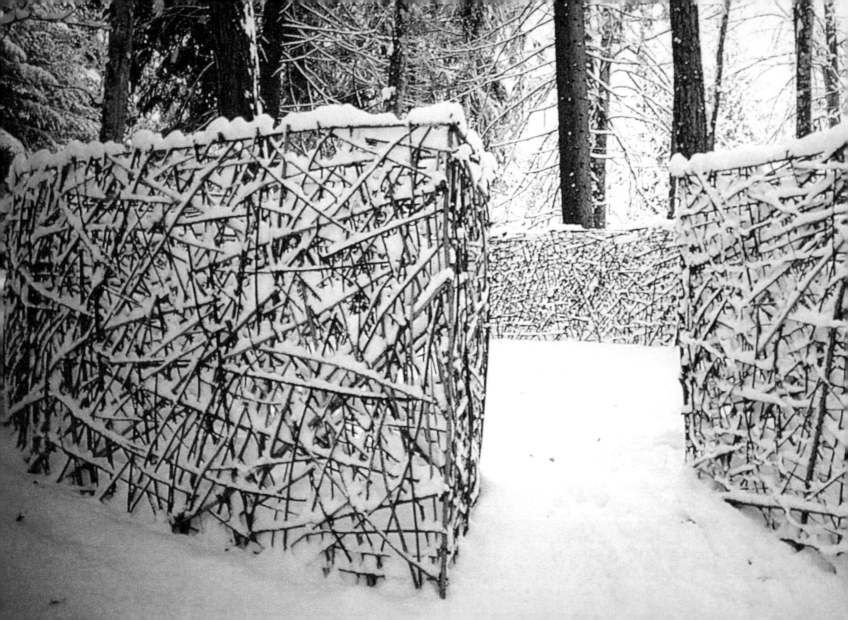

Eremo
Arte Sella
Borgo Valsugana, Trento, Italy, 2006

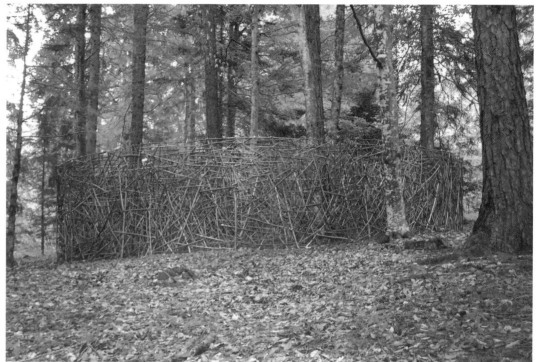

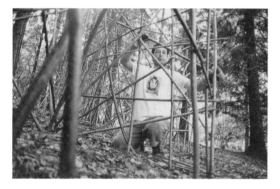

Eremo is an environmental sculpture in the Arte Sella sculpture park in Trentino Alto Adige. It was created by weaving together thousands of sticks and branches that van der Merwe collected in the woods. The circular sculpture, which stands in a peaceful corner of the park, is 65 feet (20 meters) in diameter and stands about 7 feet (2 meters) high. People can go inside the circle, which offers a quiet spot for meditation. The surrounding woodlands are an integral part of the sculpture itself, making *Eremo* a truly site-specific work of art.

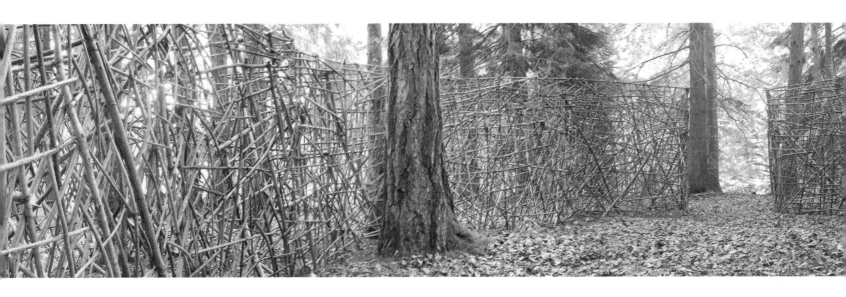

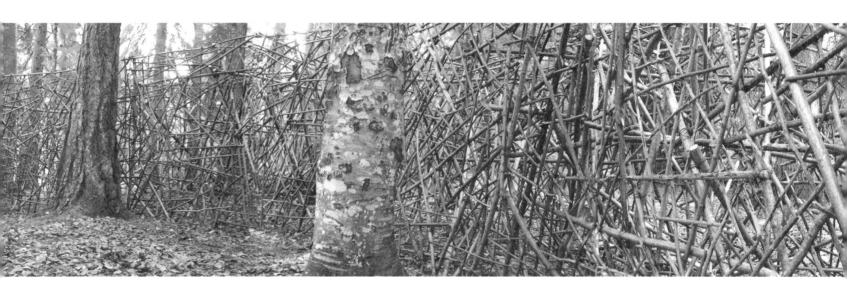

DOUG & MIKE STARN

"Big Bambú is a vast continuously constructed object, an organism reaching outward, touching ground again, and then reconstructed from its own materials, persistently moving forward. This idea, for us, is about cultures, societies, relationships, me, and the world itself, all these are made of countless pieces and these pieces are catalysts—each catalyst is connected in some way to another catalyst, and simply through their existence and progressive time they effect a change, and eventually what these catalysts are a piece of is completely different from what it once was, yet still completely and undeniably the same thing."
—D&MS

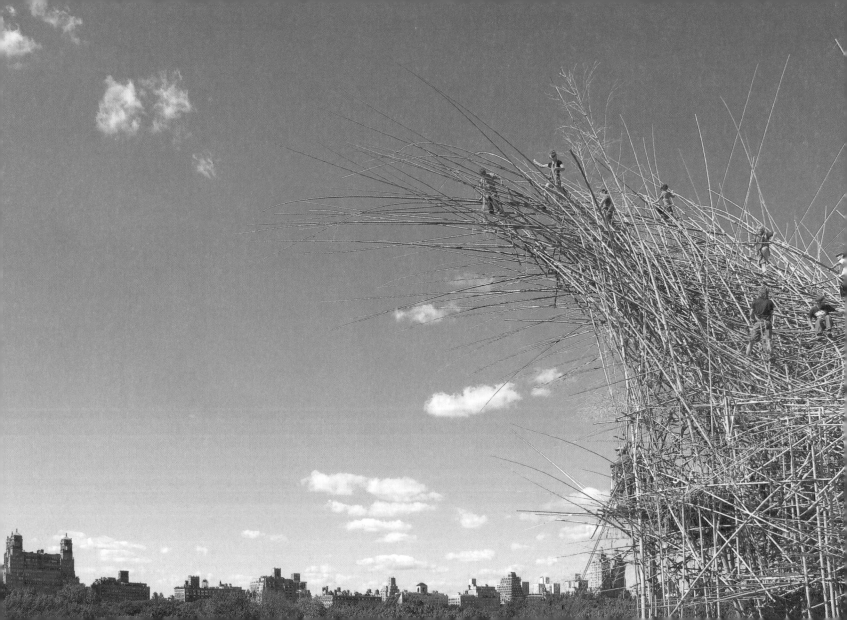

Big Bambú: You Can't, You Don't, and You Won't Stop
Metropolitan Museum of Art, New York
April–October 2010

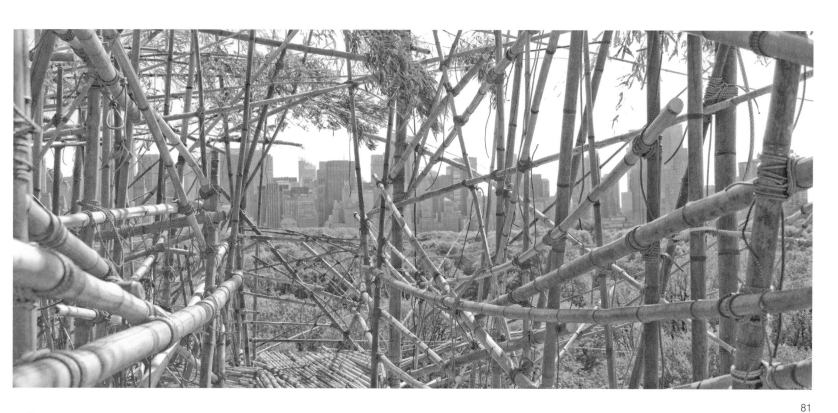

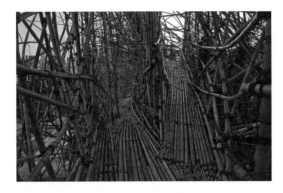

In 2010 American artists Doug and Mike Starn's *Big Bambú: You Can't, You Don't, and You Won't Stop* at the Metropolitan Museum of Art in New York had the fourth highest number of visitors of any modern art installation in the world: 631,000 people came to view it during its six month tenure. The Starn brothers and their team of climbers and builders continuously "sculpted" this enormous and constantly evolving object, ultimately using 7,000 bamboo poles on it. This piece of "performance architecture" took the shape of an enormous wave, 70 feet high, that overlooked Central Park. *Big Bambú* resembled a large and complex living organism that was constantly growing and changing.

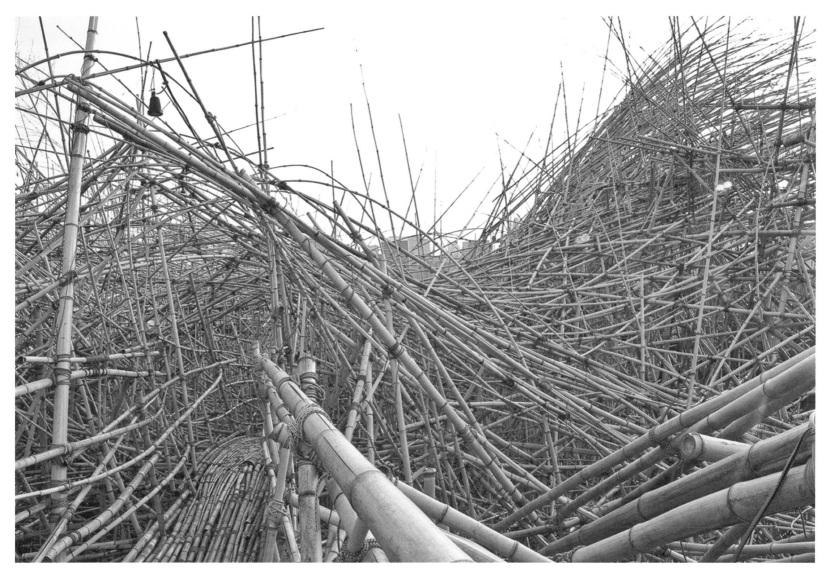

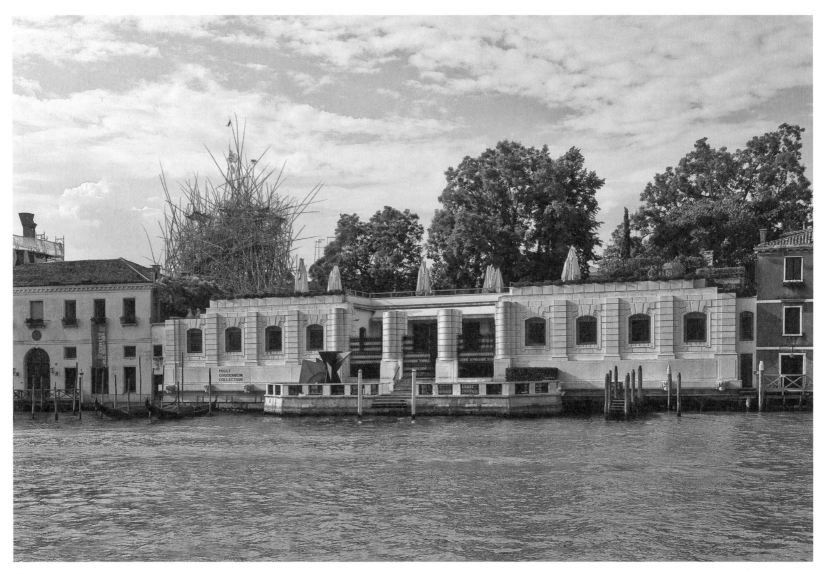

Big Bambú
54th Venice Biennale
Related installation
Casa Artom, Venice, April–June 2011

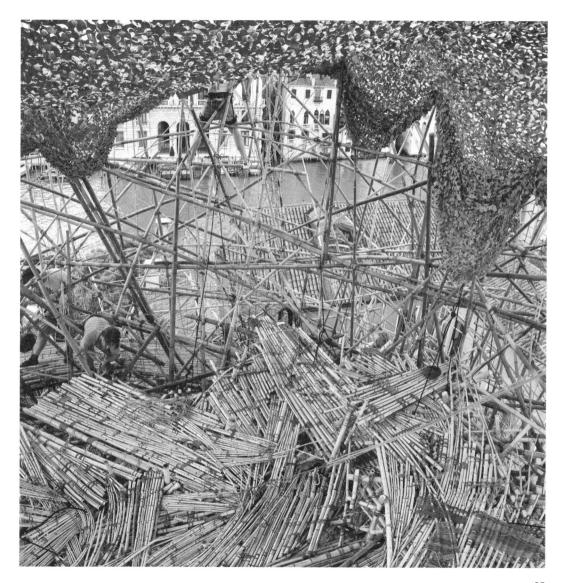

Big Bambú moved to the Grand Canal for the 54th Venice Biennale. There, the Starn twins created a spiraling tower of bamboo almost 50 feet (15 meters) tall. A path spiraled upward to the top, where visitors ascended to a large platform to enjoy the view. The installation was ever-changing: the artists and their team of climbers continued to weave in bamboo, so that the tower grew taller day by day until the exhibit ended.

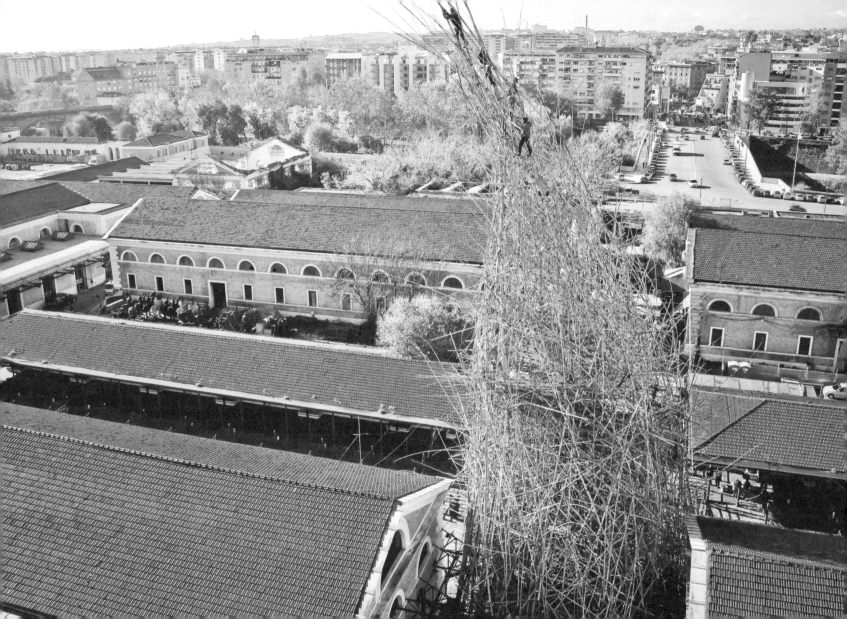

Big Bambú
Enel Contemporanea 2012
MACRO Testaccio, Rome, 2012
Curator: Francesco Bonami

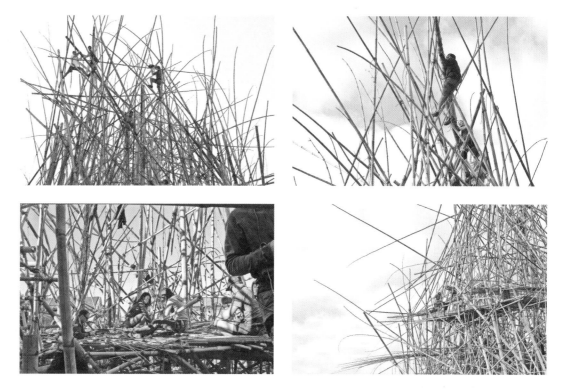

Big Bambú was also featured as a large-scale site-specific installation at the sixth edition of Enel Contemporanea. It was made by weaving together thousands of bamboo poles of different sizes and diameters; the resulting structure is over 80 feet (25 meters) high. The work was donated to the city of Rome by Enel to mark the company's fiftieth anniversary. It has become a symbol of the MACRO museum of modern art and the Testaccio neighborhood. The team that created the installation consisted of a crew of twenty-five Italian and American professional climbers. Inside the structure, visitors find a stage for performances with room for an audience of about fifty people. A double-helix staircase and various paths crisscross *Big Bambú* and lead to two seating areas that are both 50 feet (15 meters) in the air. The structure can host 80 to 120 visitors at a time; they are allowed to move about the installation freely.

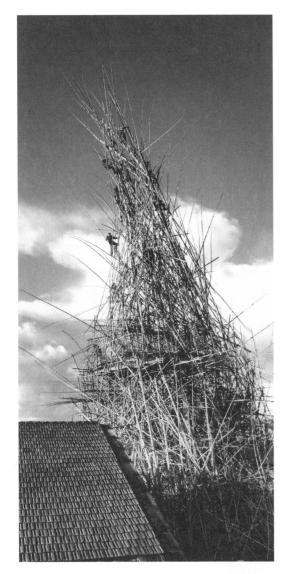

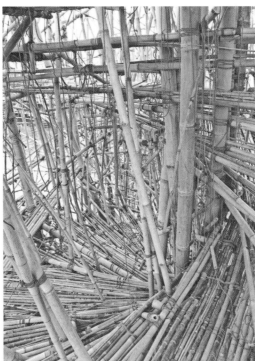

"Through this work, the Starn brothers have shown that it is possible to create one of the very few pieces of contemporary art that despite being presented as a sculpture embraces organics and life and demonstrates the ability to draw in the spectator and englobe the viewer as an integrating part of the process….These sculptures, albeit of enormous dimensions, are in no danger of expressing neither monumentality nor self-celebration. The series in bamboo is in reality an 'anti-monument' that lauds the creative process and conviviality…a 'magical' piece of architecture and sculpture that answers to the individual's culture rather than a collective one despite being the fruit of a collective effort….It is not a piece that can be banally termed ecological. It is biological. From its conception to its realization to ultimately its fruition, this piece has always been alive."
—Francesco Bonami, curator.

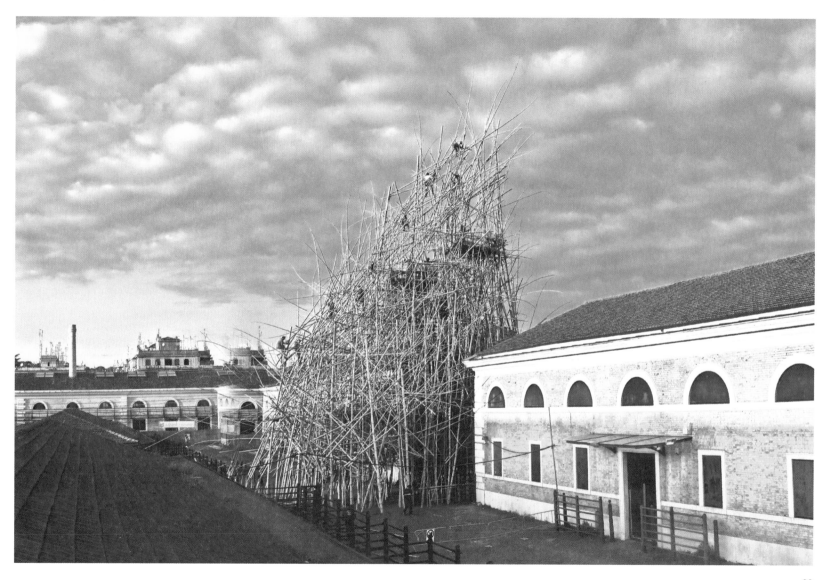

ARNE QUINZE

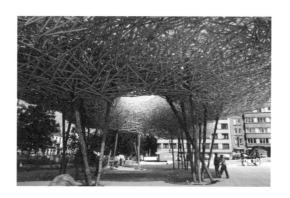

*"There's no such thing as chaos in my world. Or maybe
I should rephrase that: chaos does exist, as a form
of structure. Chaos is irretrievably linked with life."*
—AQ

Cityscape
Brussels, September 2007–February 2009
59 x 213 x 66 feet (18 x 65 x 20 meters)

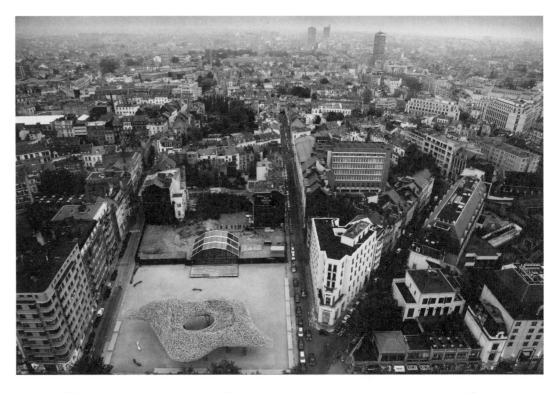

For close to a year and a half, the Louise neighborhood of Brussels was animated by *Cityscape*, an impressive sculpture by Arne Quinze. The 58.5-foot-high (18-meter-high) structure sat atop 39-foot-high (12-meter-high) poles and measured 131 feet (40 meters) long and 82 feet (25 meters) wide. *Cityscape* attracted the residents of Brussels like a magnet. People were encouraged to come from all over the city to interact beneath it, investing the area with new energy. *Cityscape* almost seemed to flutter in the air as it offered shelter and a serene place for contemplation. The installation became a means of communication in its own right. Rays of sun filtered through the wooden beams, creating a spectacular play of light and shadows in continuous movement.

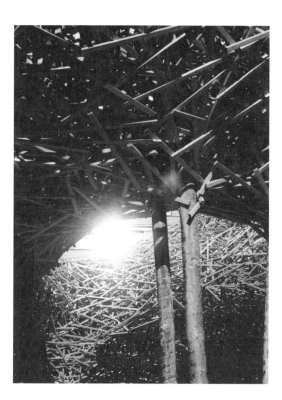

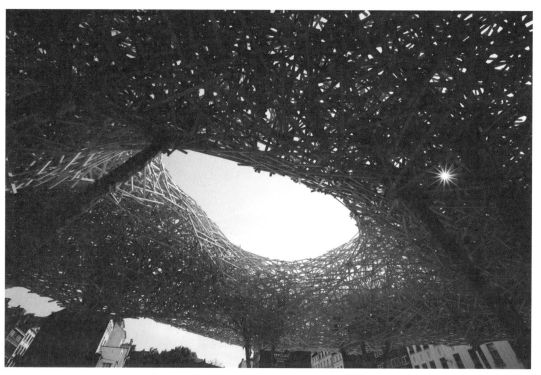

"Communication between people is an important starting point for my monumental works....I used the wooden installations to examine how you can bring people together in a city today. There's something very warm and nurturing about wood. People like to stand under one of these structures as if they are seeking shelter together. It creates a tie—they are connected with one another for an instant. That's what it is all about for me. I want to create meeting places in the city with my work. In the past, for example, a marketplace was a place where people gathered to meet one another. Today it no longer has this social function, which is sad.

"Nowadays when you walk around a city and greet people, most people are shocked or, in the worst case scenario, even become aggressive. We are no longer used to this daily interaction, even though we spend massive amounts of time on Facebook and on Twitter. A city has many rhythms, which overlap, and different social groups, which unfortunately talk to each other increasingly rarely. The main motive of my public installations is to make people communicate with each other again."
—AQ

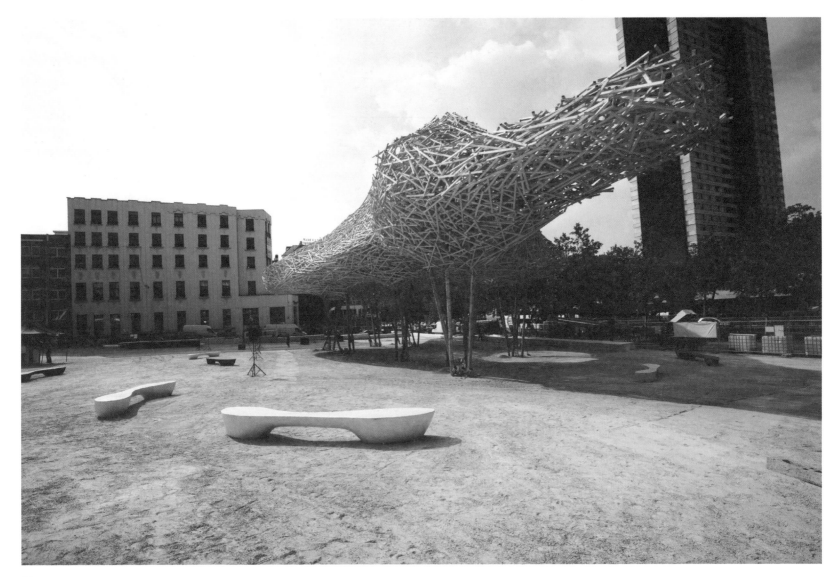

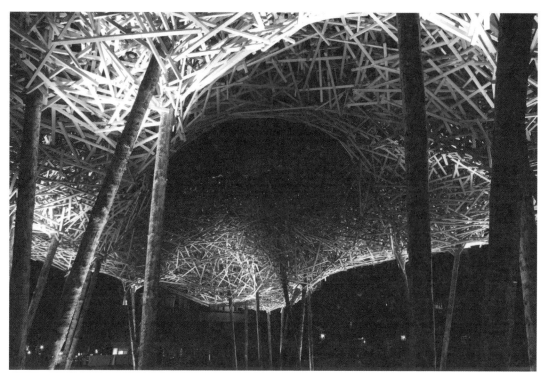

The installation was initially scheduled to stand for one year only, but due to popular demand its closure was postponed. Still, *Cityscape* was a temporary installation. In 2009 it was finally dismantled, leaving an empty space in the city and an empty feeling in the hearts and minds of its residents. The wood from the sculpture was all recycled as construction material.

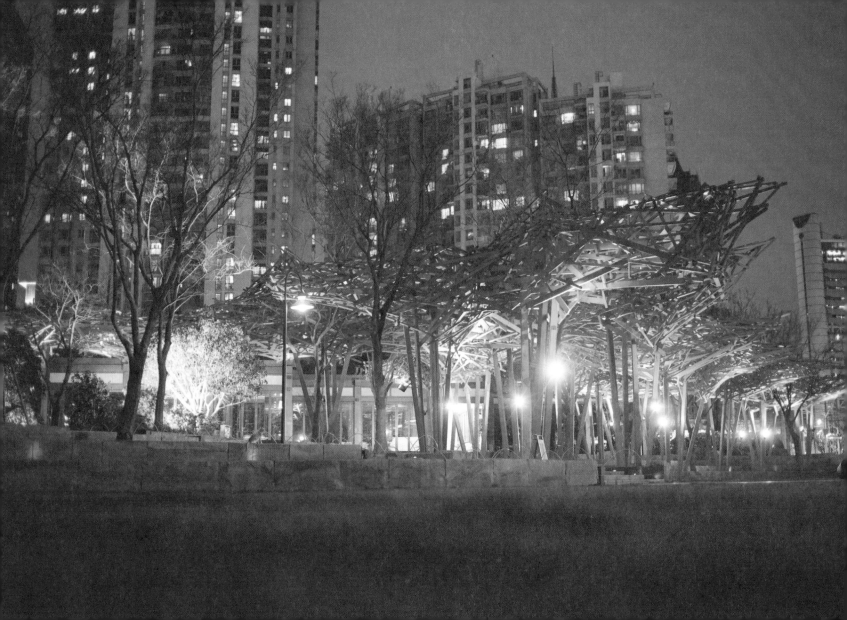

Red Beacon
Jing'an Sculpture Park, Shanghai
August 2010–August 2020
11 x 80 x 30 meters

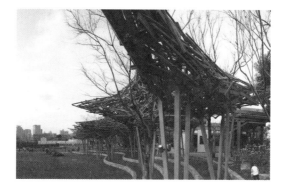

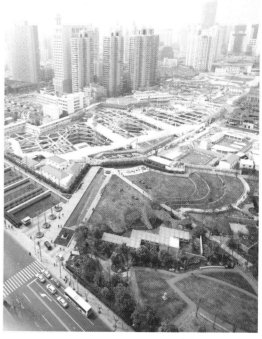

Through his work, Quinze hopes to revive a spirit of social interaction. *Red Beacon* captures the attention of passersby and draws them into the Jing'an Sculpture Park with its lively red color and shape. In this peaceful environment, people sit and interact with the sculpture.

Jing'an Sculpture Park is part of the Jing'an International Sculpture Project, a high-profile public art event in Shanghai organized by the Jing'an District local government and the Shanghai World Expo coordination department. The park was one of the first places in Shanghai to host public art, and Quinze's piece in particular represents a major urban and cultural improvement for Shanghai by offering a place where people can meet and communicate freely.

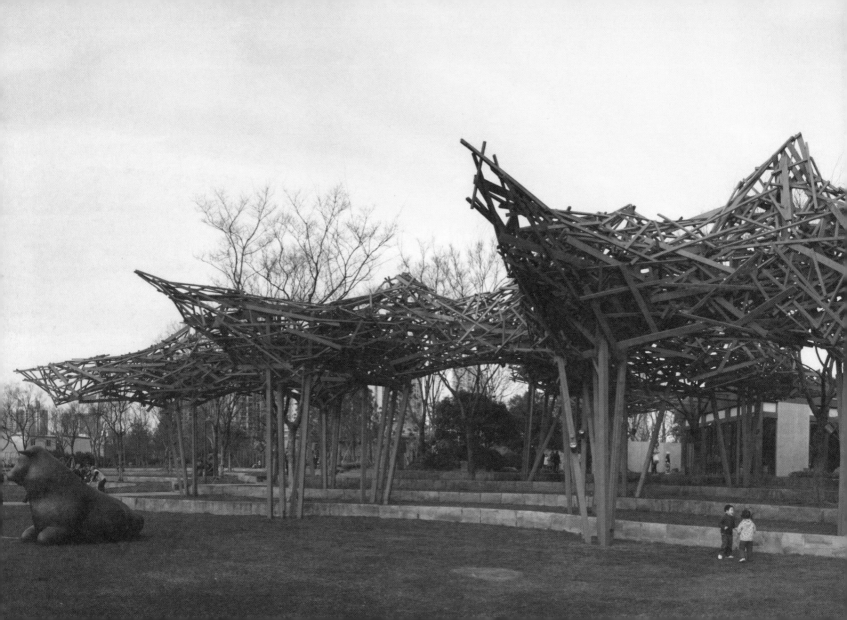

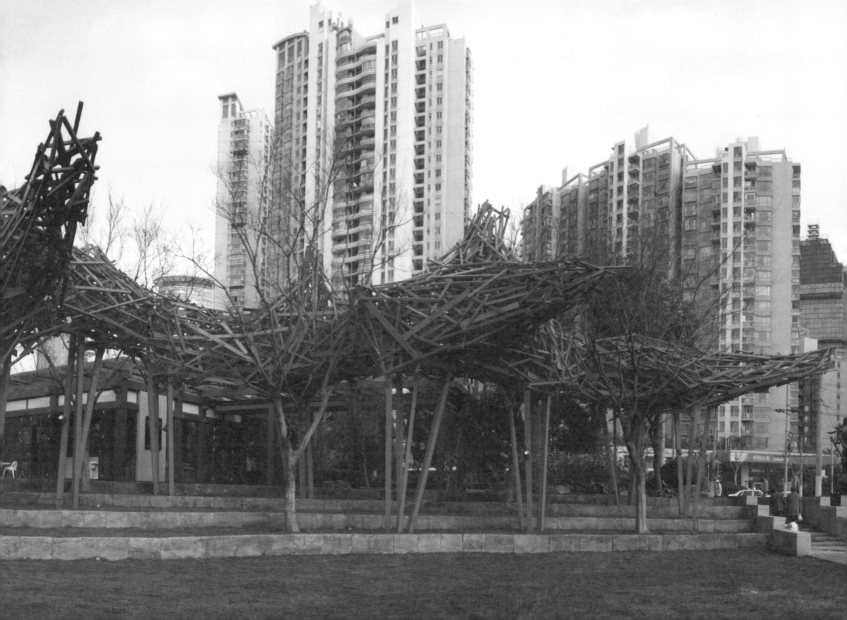

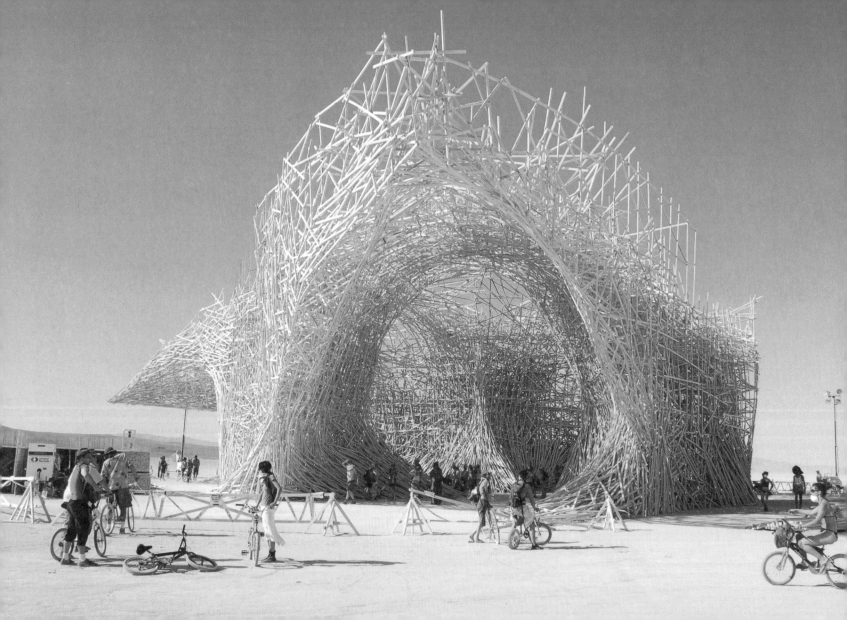

Uchronia
Black Rock City, Nevada Desert
September 2006
25 x 60 x 60 meters

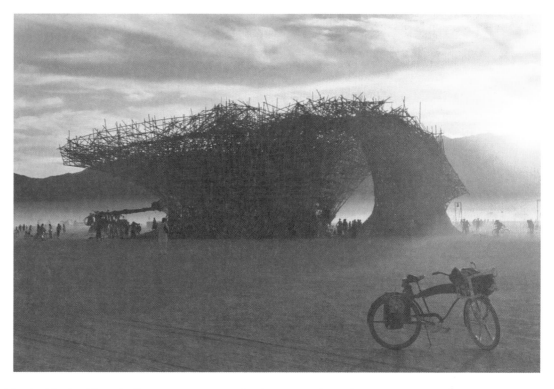

This installation, built for the 2006 Burning Man Festival in the Nevada Desert, was created using approximately 93 miles (150 kilometers) of wood in pieces 3, 6, and 9.5 feet (1, 2, and 3 meters) long. A team of twenty-five builders took three weeks to complete the sculpture that stood 50 feet (15 meters) high, with a surface area of 195 by 90 feet (60 by 30 meters) at its base. The perspective from inside the sculpture evoked walking inside a giant womb. At the end of the seven-day festival, the sculpture was set on fire as a symbol of transition. Seeing this enormous structure go up in flames elicited a highly emotional reaction from spectators, and it became one of the most memorable and talked about events of that year's festival. And that, ultimately, is the goal of Quinze's work: to get people to communicate in any possible way.

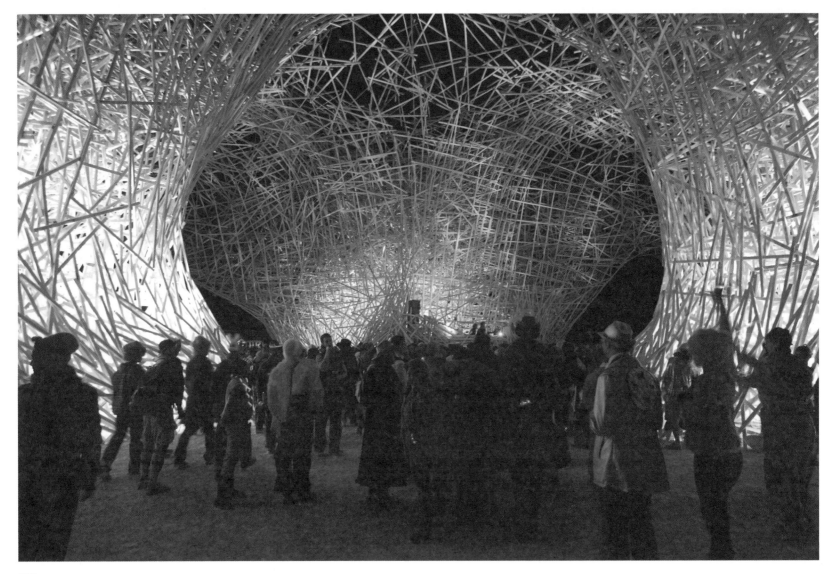

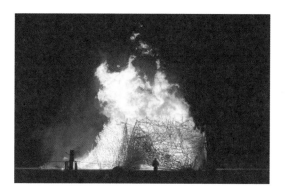 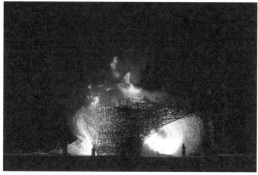

"As an artist I have arrived at a stage in my life where I wish to make a gesture....I have made this work to share it with the public. The main thing is not to see my name on this work of art. I am interested in the installations and their impact on people and cities. My dream is to turn cities into interactive open-air museums. The higher the level of cultural education, the higher the population's level of civilization. If you live your life surrounded by a lot of art, your perception of the world will be enhanced and you will be able to see things in a perspective more easily. You will set yourself goals that are different from the most evident ones. That is why I wish to give people a gift of art that they cannot ignore, which is not safely ensconced in a museum."
—AQ, Cities Like Open-Air Museums

STUDIO WEAVE

"At Studio Weave, we are fascinated by the powerful role that stories play in creating a sense of place, both as a design tool and a way to engage with everyone surrounding a project, including clients, consultants, and users, both grown-ups and children. We are always on the lookout for alluring narrative arcs to inform our proposals, and it is imperative for us that these grow from the inherent characteristics of the site, and are never forced or overlaid where they do not belong."
—SW

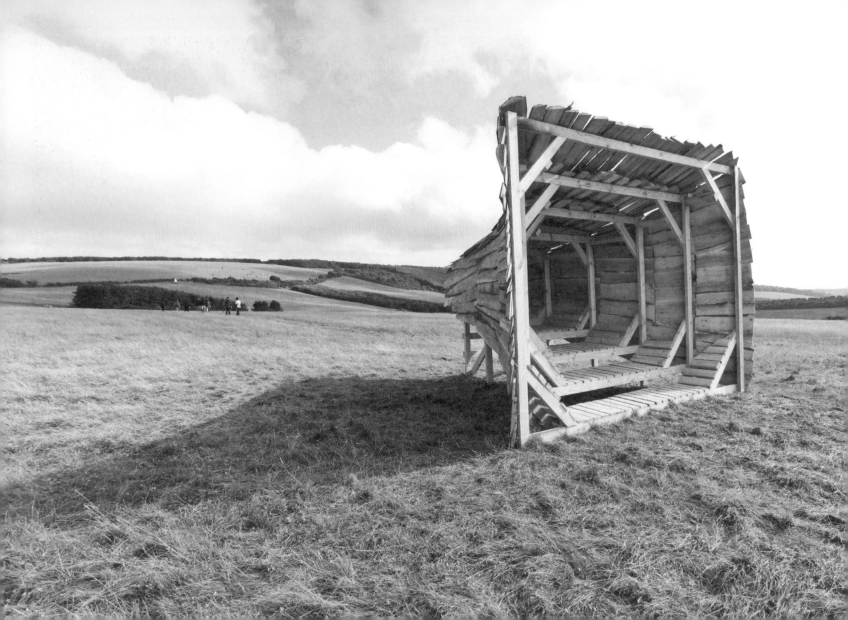

Landscope
Studio in the Woods
Isle of Wight, United Kingdom,
summer school 2011

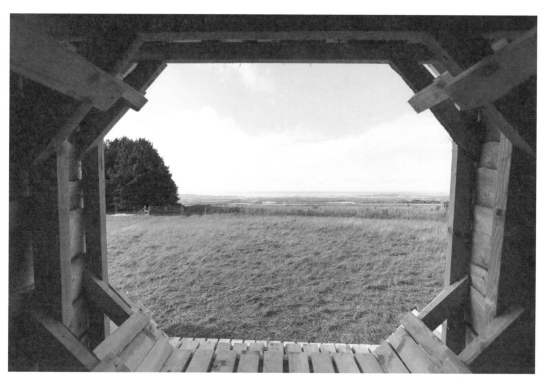

Studio in the Woods is a design and construction workshop for architecture students, architects, and anyone else interested in manual labor and construction with wood and other natural materials. In 2011 Studio Weave ran a Studio in the Woods summer workshop on the Isle of Wight. Early in the summer, the assembled group decided on the project and concept to be developed, as well as the location for the resulting structure, titled *Landscope*.

"We scaled the highest hill at New Barn Farm, where we found ourselves seduced by the view of the Solent and so decided to build a structure to frame it called the Landscope.*"*
—SW

"We made six timber frames of decreasing size then used off-cuts to clad the structure and create a shelter for enjoying views."
—SW

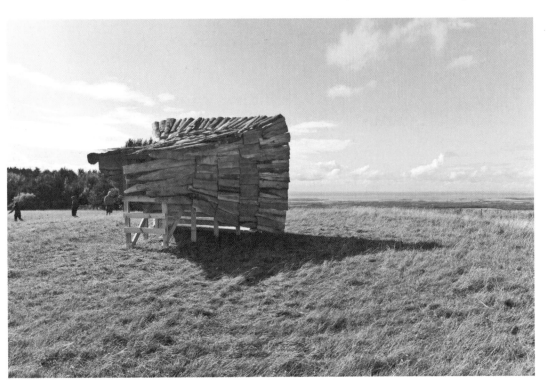

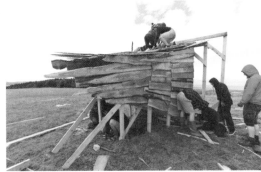

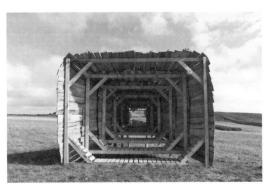

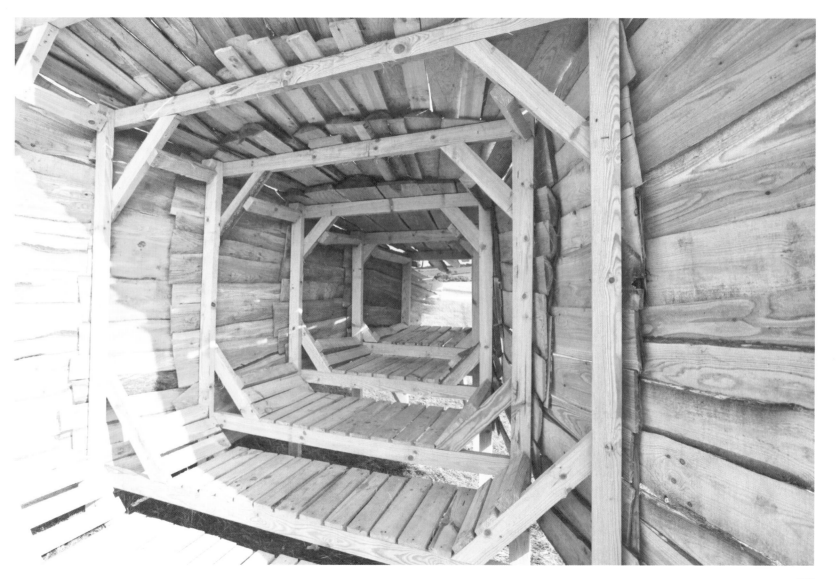

Fire Folly
Studio in the Woods
Isle of Wight, United Kingdom,
summer school 2010

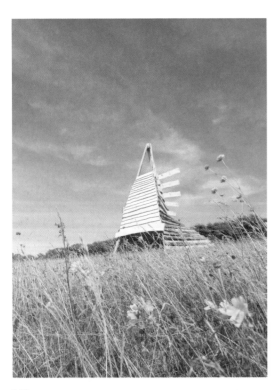

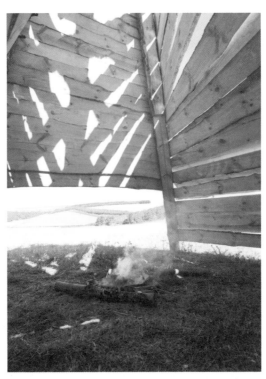

In the summer of 2010, Studio Weave ran a three-day construction workshop as part of its Studio in the Woods series. The goal was to create a work of micro-architecture that could become a new landmark in the area. That led to the concept for *Fire Folly,* a small shelter with a fire pit inside.

The building was approximately 23 feet (7 meters) tall and was made entirely of black pine. The front was painted with a chalk- and water-based paint so that it would be starkly visible from a distance. The main structure, anchored by three poles attached to each other, was built at ground level and then raised vertically, with the exterior facade attached to complete the structure.

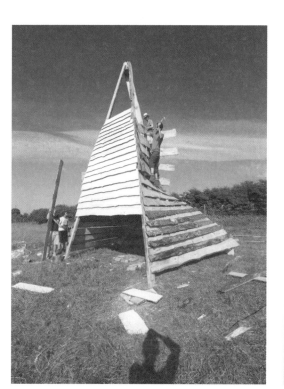

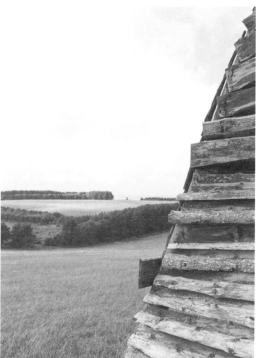

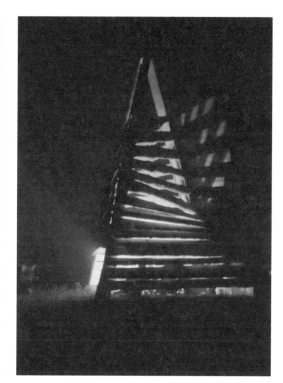

Freya and Robin
Kielder Art and Architecture
Northumberland County,
United Kingdom, 2009

This project entailed creating two
small works of architecture on opposite
banks of the Kielder Water reservoir
in Northumberland County. These
serve as rest areas and meeting places
for visitors to the lake.

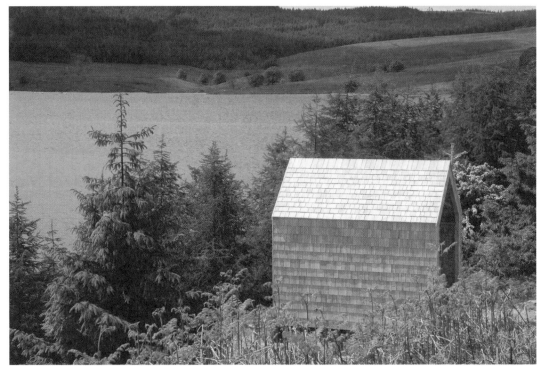

The legend of the lake, the story of Freya and Robin, speaks of water, woods, and the natural environment. The goal of this project was to tell a story and create elements in harmony with the site.

"We like to think of the area as a stage set or backdrop against which we can tell a story."
—SW

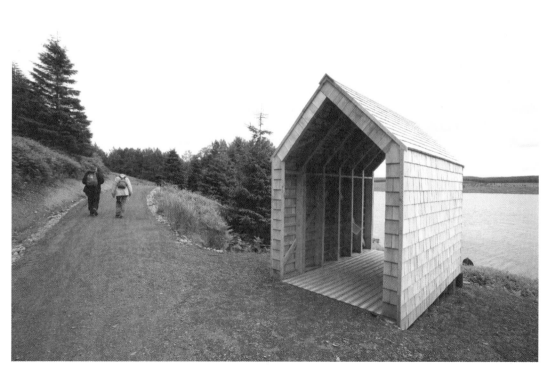

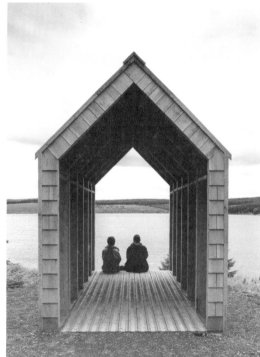

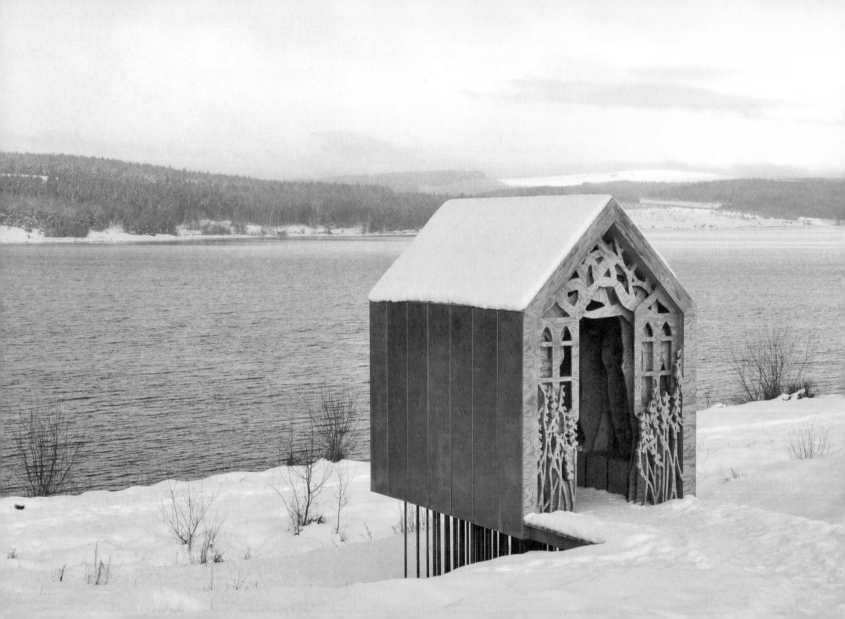

"Robin's Hut is on the north bank, on the edge of the woodland amongst fir trees and rocks. It's a wooden hut on the edge of the lake, immersed in the woods. Freya's cabin, built to express her love for Robin, is located on the opposite shore of the lake, directly in front of Robin's. In the meantime, Robin built a boat. Freya thought he was going to use it to come to her, but Freya's cabin was on the south shore, and when Robin looked in that direction the sun was in his eyes, so he didn't know she was there. He was planning to use the boat to go on an adventure. When Freya realized that Robin was heading away from her, she began to cry tears of gold, which covered her cabin. Robin saw something shining in the distance and headed toward it. He was so moved by the cabin that Freya had built in his honor that he asked her to come with him. Freya and Robin are still traveling today, but the wooden hut and the gold-covered cabin still stand on the two shores of the lake, awaiting the return of their owners."

—SW

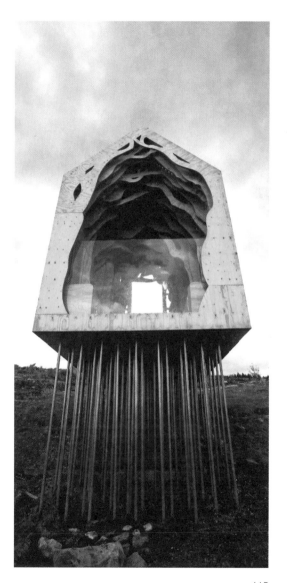

RAI STUDIO POUYA KHAZAELI PARSA

"It is a wonderful method of sheltering—far more interesting than a conventional dome—beautiful and very simple."
—Pouya Khazaeli Parsa

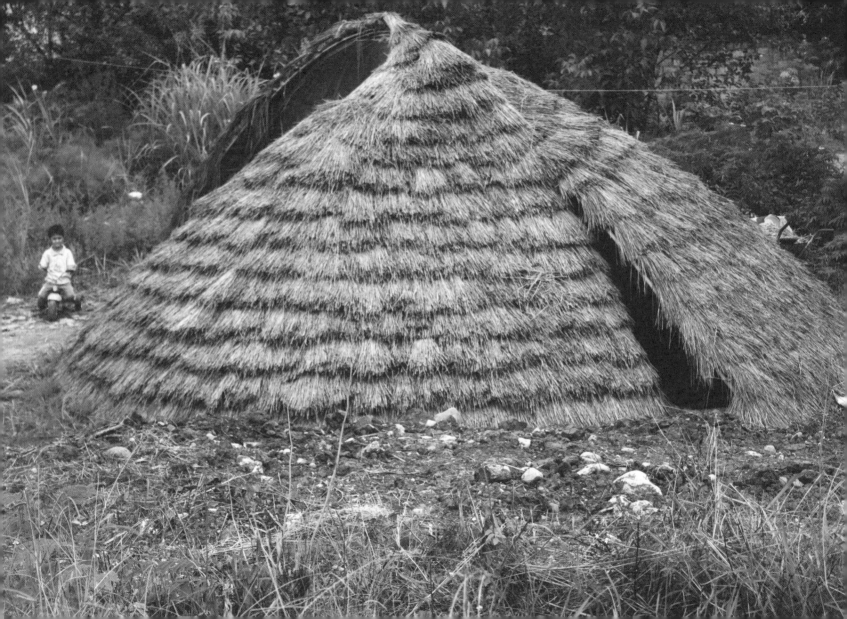

Bamboo Structure Project
Architecture for Humanity Tehran (RAI Studio)
Mirdamad Resort Town, Ramsar, Mazandaran, Iran,
March 2009
Bamboo structure, base of metal pipes, rice
straw exterior
—
Project manager: Pouya Khazaeli Parsa (RAI Studio)
Client: Manouchehr Mirdamad
Participants: Kaveh Akef, Milad Haghnejad
Construction: Javad Abbasi

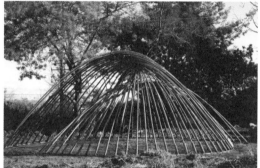
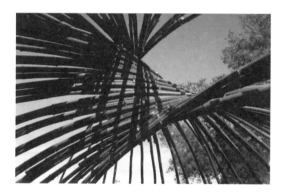

The structure is made of seventy bamboo
poles. The bamboo was harvested just
two days before construction began so that
it would remain flexible while the dome
was being shaped. Later the bamboo grew
stiff as it aged.

The base of the structure is made of metal pipes, and the bamboo poles are attached to those. The structure is not fixed to the ground but merely rests on it so that it can be moved easily. This work of microarchitecture was conceived and designed to be used as housing in emergency situations, so the design called for simple construction techniques that could be implemented quickly, as well as very low construction costs. A dome can be constructed by three nonprofessionals. A dome with an area of about 430 square feet (40 square meters) costs approximately 700 euros to build. The dome shape makes these structures very durable and able to withstand strong winds, storms, and earthquakes. There are numerous rice paddies in the area, so rice straw was used to cover the outside. Pieces of rice straw are layered on top of one another and then tied to the bamboo structure.

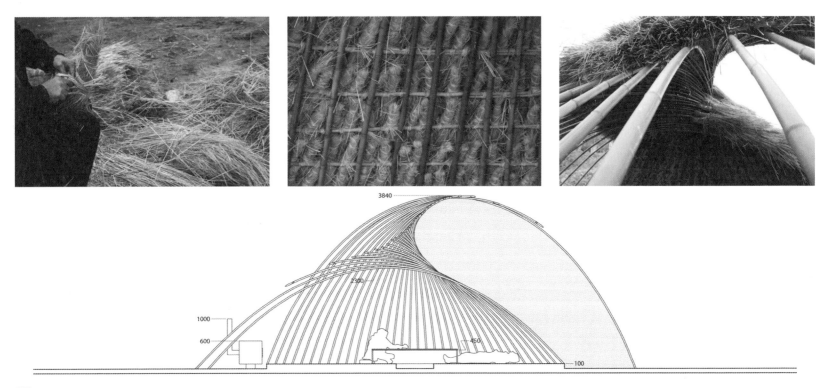

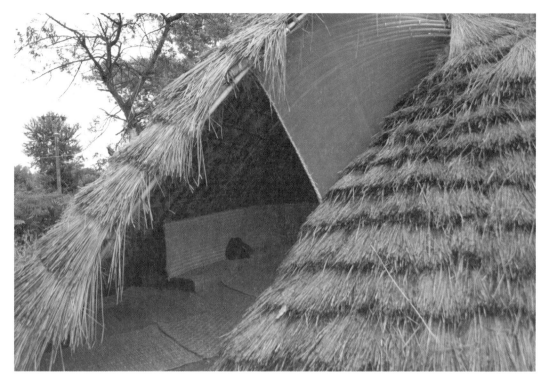

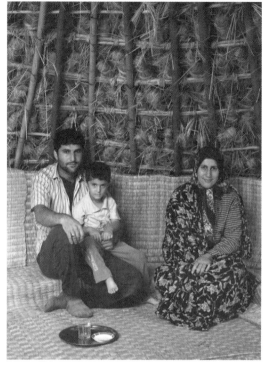

The rice straw was also chosen as an exterior covering because it has great permeability. When it gets wet, it expands and stops rain from entering inside the structure. In summer it becomes dry and porous, keeping the interior cool and providing excellent natural ventilation.

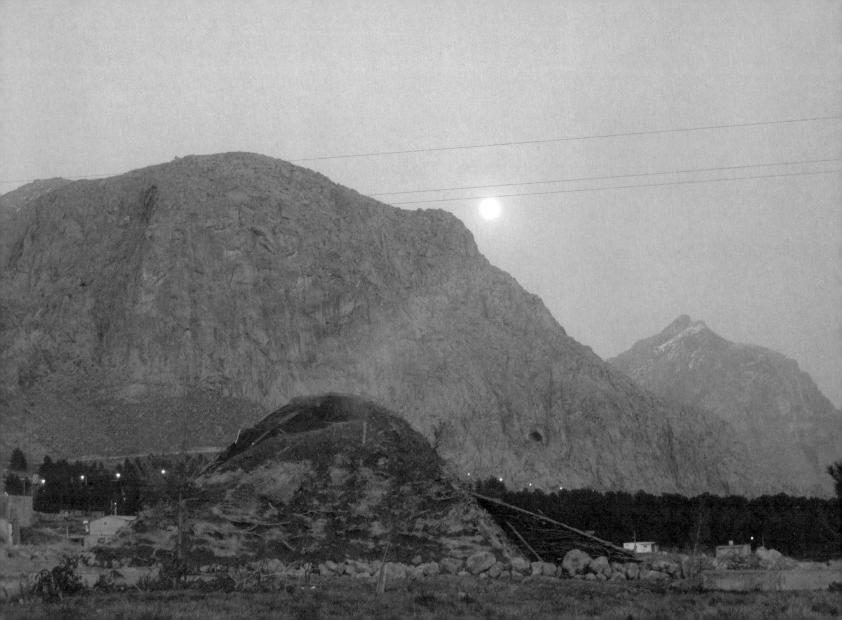

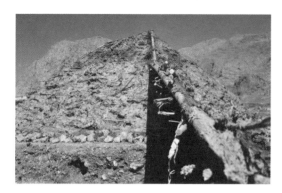

Mud Structure

Architecture for Humanity Tehran (RAI Studio) in cooperation with Razi University
Kermanshah, Iran, February–March 2012
Mud structure, branches, bamboo
Project manager: Pouya Khazaeli Parsa (RAI Studio)

—

Architecture for Humanity USA support: Ken Smith
Design team: Mohammad Pourhassani, Saman Yamini
Participants: Nastaran Shahbazi, Farzane Rafee, Zohre Yousefi, Kaveh Akef
Local coordination: Reza Torabi, Mirza Asgari, Kamyar Salavati, Soheil Taheri,
Boshra Javaheri,Maryam Shahrokhi

"After spending several months with us in our headquarters office, our good friend and colleague Pouya Khazaeli returned to his native Iran to begin work on an exploratory mud structure project in Kermanshah. He and his ambitious team of designers and university students are eager to spread the practice of humanitarian design, and have a particular interest in sustainable and inexpensive construction techniques for the undeveloped region on the border between western Iran and eastern Iraq."

"The prototype dwelling consists of a bamboo structure, tree branches, and walls made out of mud. The tree branches came from a number of trees the mayor of Kermanshah had removed for a transit project. The cost of each unit is $900 USD and the team aims to build ten to twenty dwellings in total. The 25-day workshop provided participating students with the opportunity to learn sustainable architecture construction methods complementing their academic curriculum in design. The first prototype structure will serve as a student pavilion at the University of Razi."

—Ken Smith, Architecture for Humanity San Francisco

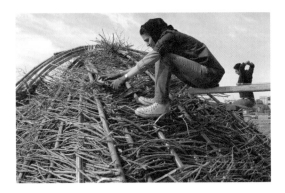
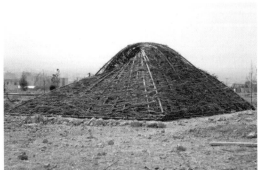
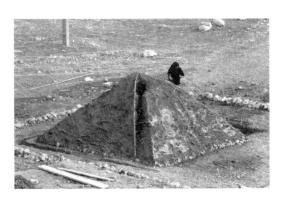

Subsequent to the workshop in Kermanshah
and experiments in the field, the group
was invited to participate in the 2012 Grains
D'Isère festival in France. One of the
goals of the festival was construction of an
ecological children's village using only
earth and mud techniques.

AL BORDE ARQUITECTOS

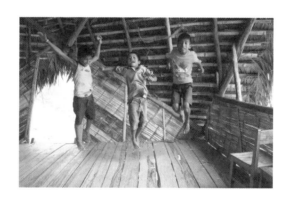

"Our new school has been a source of pride for all of us in this community. Our community is located on the beach and in the fields, in a remote location, where we fish and farm ingredients for our daily meals. Until four years ago, there was no school in the community and because of that, most of its inhabitants were illiterate. We opened our school in a small beach cottage, but as the time passed, the space was too small for the number of children—that's why we undertook the construction of a new school."
—Teacher, Nueva Esperanza School, Manabí, Ecuador

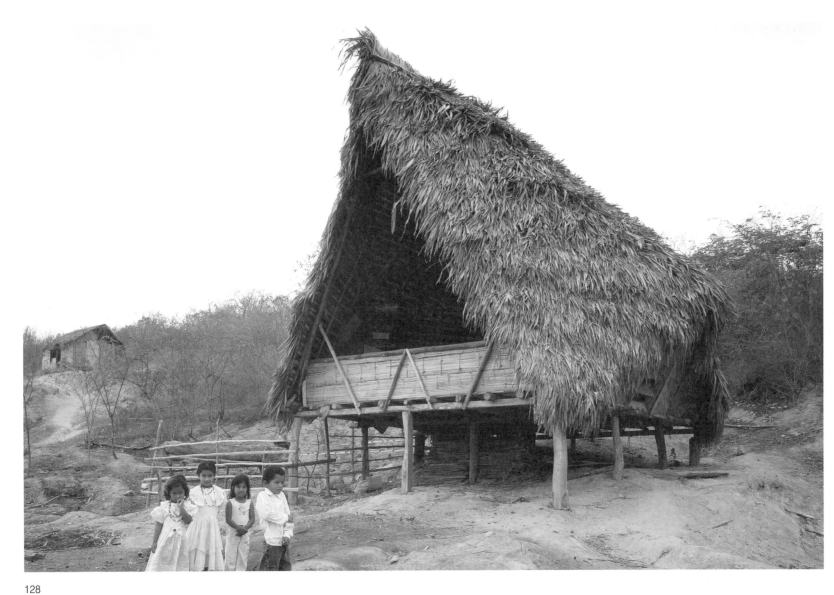

Scuola Nueva Esperanza
Manabí, Ecuador, 2009

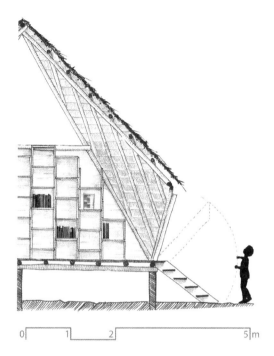

One of the priorities of the design for this village's school was to foster an atmosphere in which education is an active process. The project also had to be connected with the surrounding environment—a place where children's imaginations, creativity, and desire to learn could grow. The construction materials and methods were based on those the community has always used: a timber base on raised foundation poles, bamboo walls, a wooden structure, and a straw roof. The difference lay in the concept and the layout.

Total construction cost: $200

- Untreated wood: $60
- Bamboo: $40
- Hardware: $50
- Miscellaneous: $50
- Labor—self-built: $0

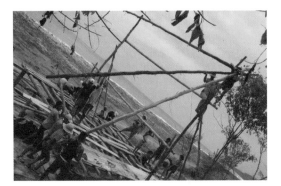
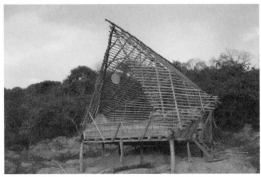
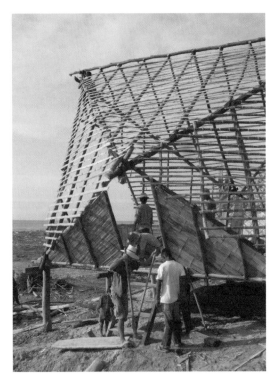
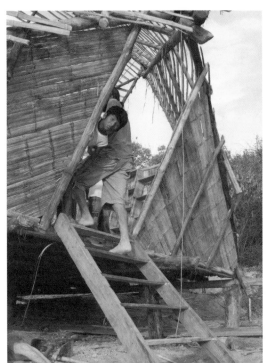

"In our fishing community, it's great to have a school in the shape of a boat where every day, kids jump into it and get ready to sail and discover new worlds thanks to their own potential and skills. It's a place where children learn science and technology, becoming aware of the value of life and learning lessons from the best teacher of all—nature."
—Teacher, Nueva Esperanza School, Manabí, Ecuador

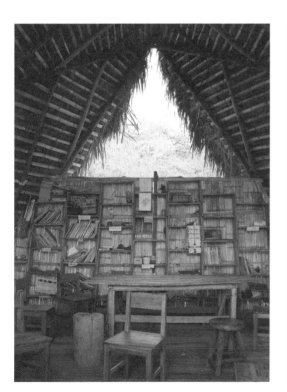

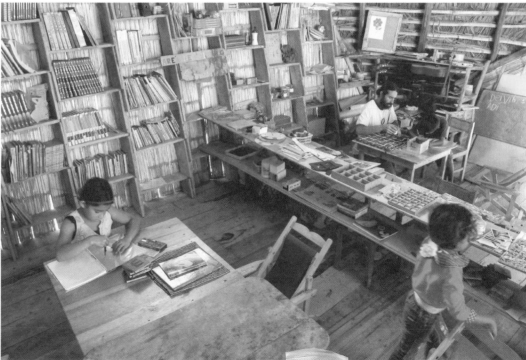

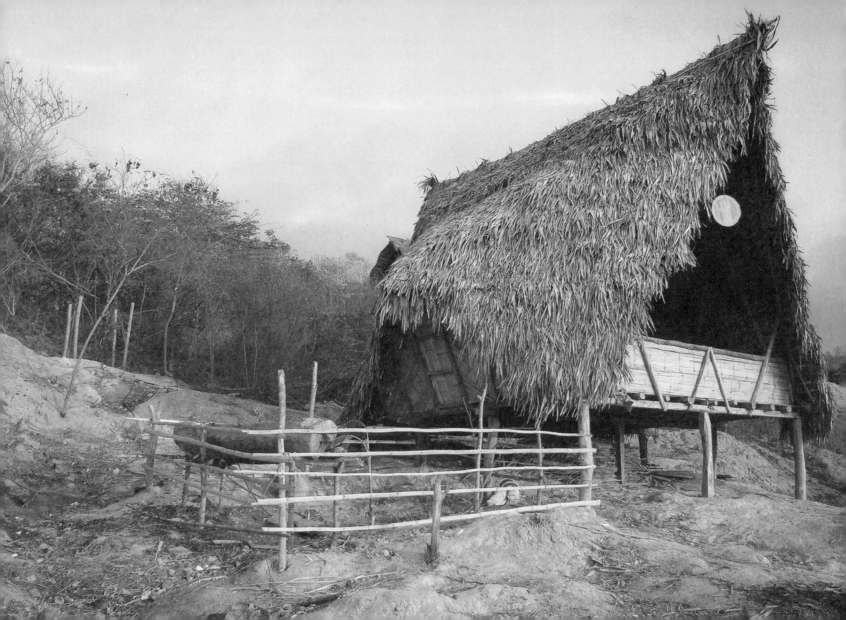

With the Esperanza Dos project, a new school and a place for community gatherings was
built in Manabí with an eye toward future adaptability. The goal was not just to construct
a building with the help of the residents of the village, but to share the logistics of
the construction process as it was underway so that everyone involved would learn
the construction processes and methods.

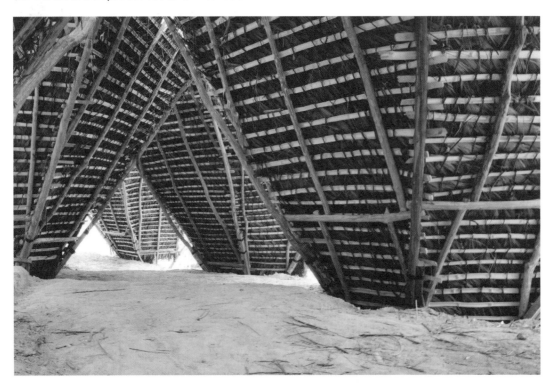

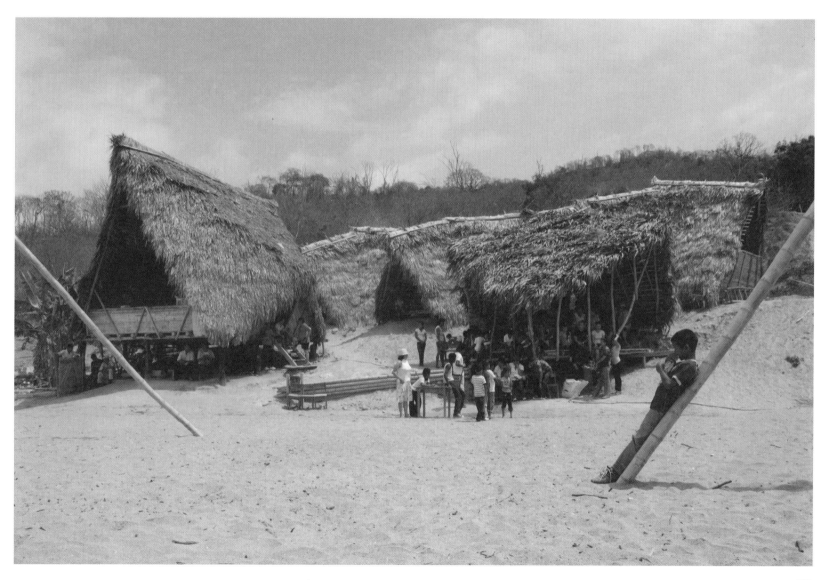

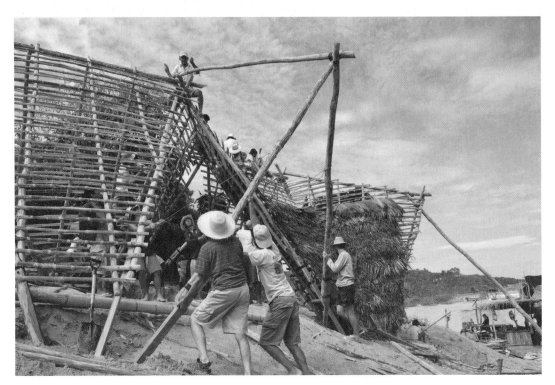

The project was thus built without the use of topographical maps, AutoCAD, or 3-D design programs. A simple construction system with minimal complexity was needed—one that could be easily adapted to the variables of the site, such as the topography of the land, as well as available construction materials and labor. The system needed to be open to discussion in the field so that any challenge that might arise during construction could be addressed.

Every individual was assigned a task during the construction, and they naturally became practiced at performing those tasks, so much so that they perfected techniques and helped optimize the construction process. Upon completion, it was clear that the techniques the team had utilized had been developed further by everyone involved. The community had truly made the process their own, and later expanded the building and equipped it with wooden floors and bamboo walls.

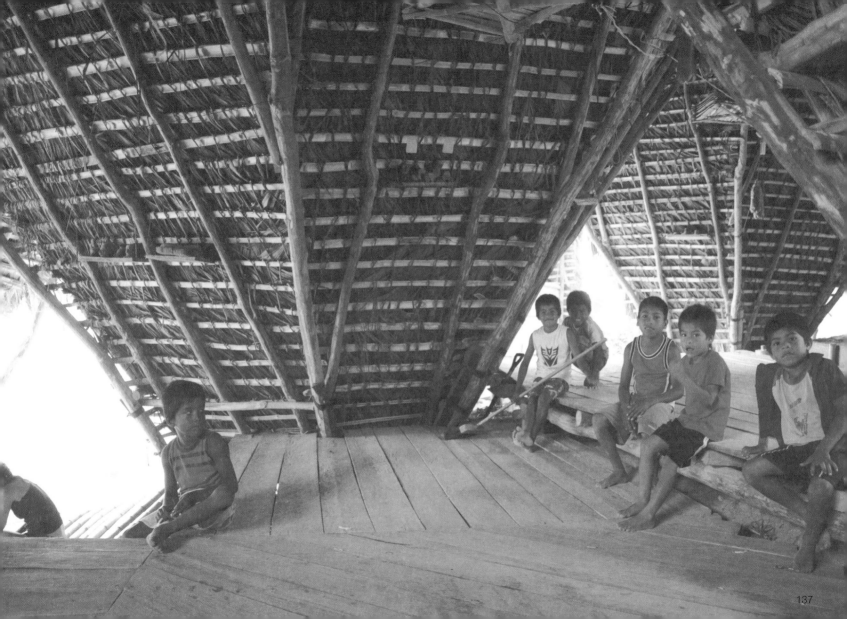

MARCO CASAGRANDE

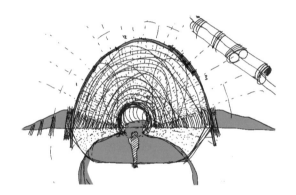

"Inside the Sandworm you are greeted by a natural spectacle of light and shadow. I was amazed. The artist believes that architectural control goes against nature and thus also against architecture. The built human environment is a mediator between human nature and nature itself. To be part of this, man must be weak. To the Finnish artist Marco Casagrande, designing is not sufficient. Design should not replace reality. The building must grow out of the location, it must react to its environment, it must be a reflection of life and also be itself, as every other living being."
—Peter Beyen

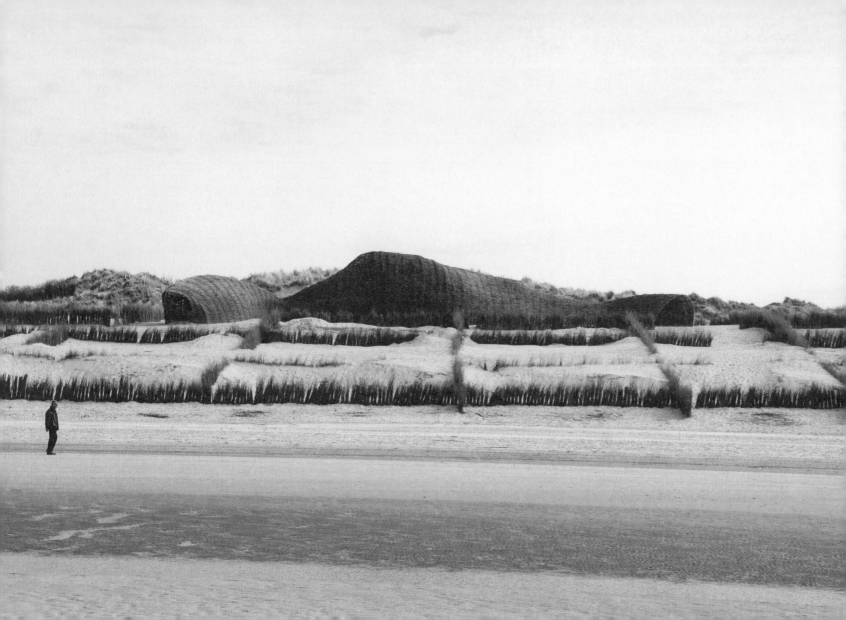

Sandworm
Wenduine, Belgium, 2012

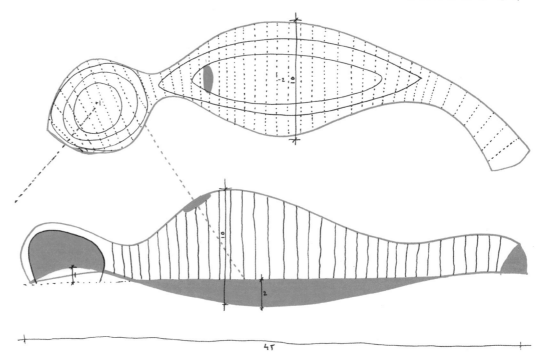

Built on the dunes of the Wenduine coastline in Belgium for the Beaufort Triennial of Contemporary Art by the Sea, *Sandworm* is a site-specific installation that pushes the envelope of environmental art. Based on a local tradition of building with sand and willow branches, the load-bearing structure comprises willow branch arches of various sizes and heights that are then covered with a "fabric" of thinner branches, which define the shape and make the structure rigid. *Sandworm* is 148 feet (45 meters) long and 33 feet (10 meters) wide and 33 feet (10 meters) high at its highest point.

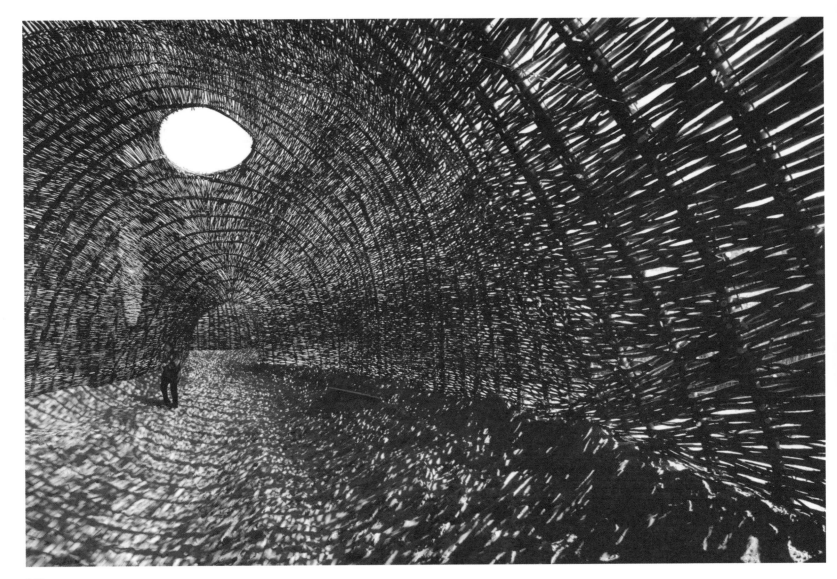

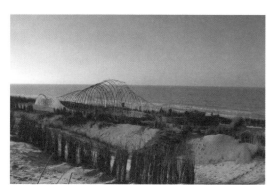

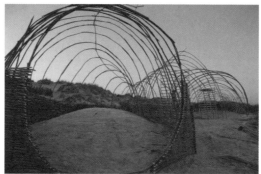

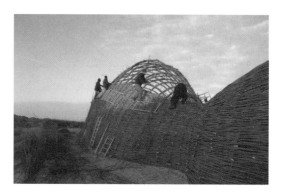

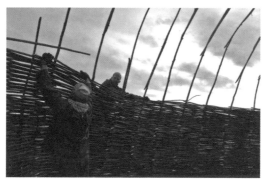

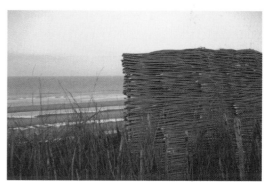

Casagrande and his team worked for four weeks in close contact with local professionals, experts in traditional willow branch construction, in order to make something that Casagrande has termed "weak architecture," meaning a man-made structure with such an organic presence that it becomes part of nature.

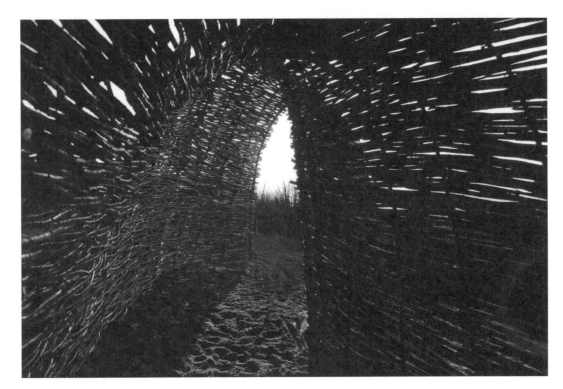

Sandworm offers shelter from the wind and sun, but it also allows visitors a chance to appreciate the play of light and shadow under its roof. Visitors experience it as a natural, plant-based cathedral that pays homage to the movement of the water and sand in the landscape along the Wenduine coastline.

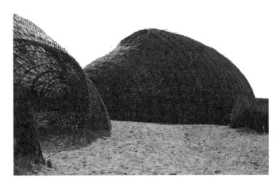

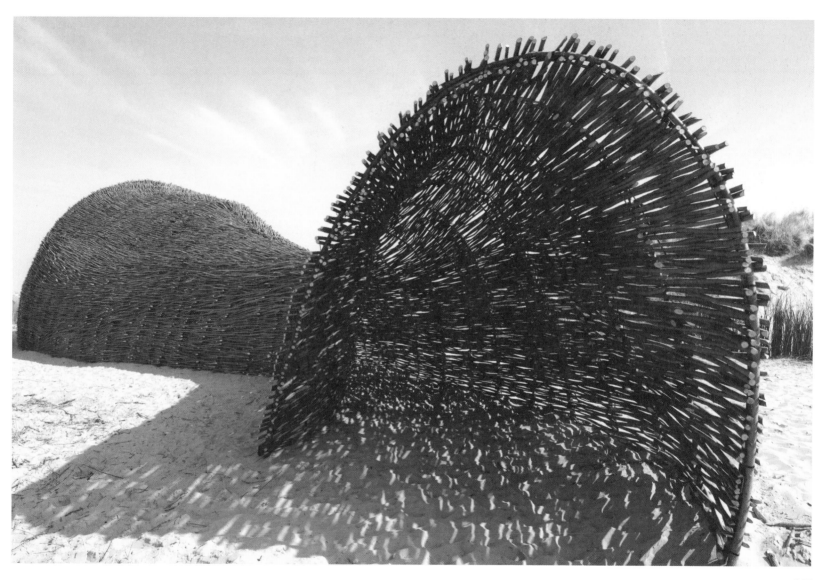

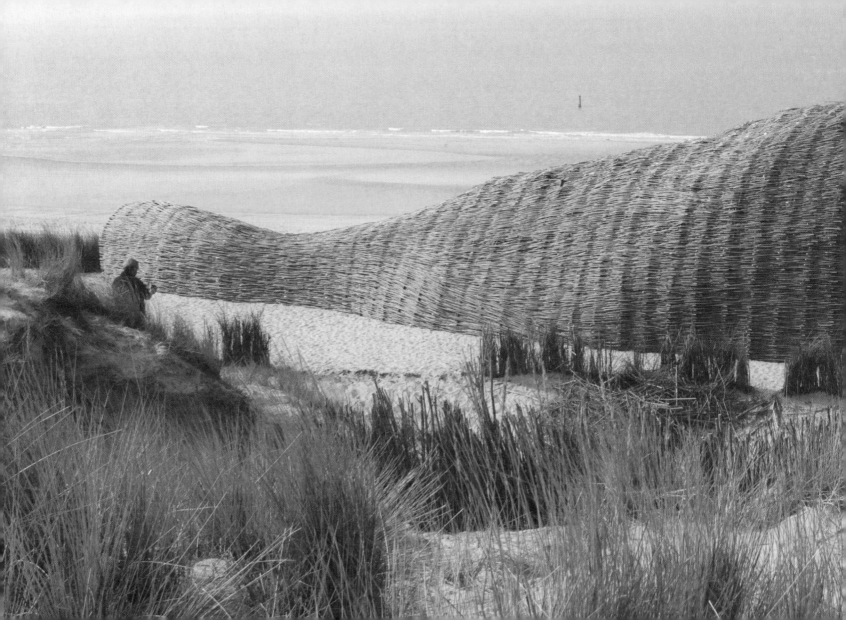

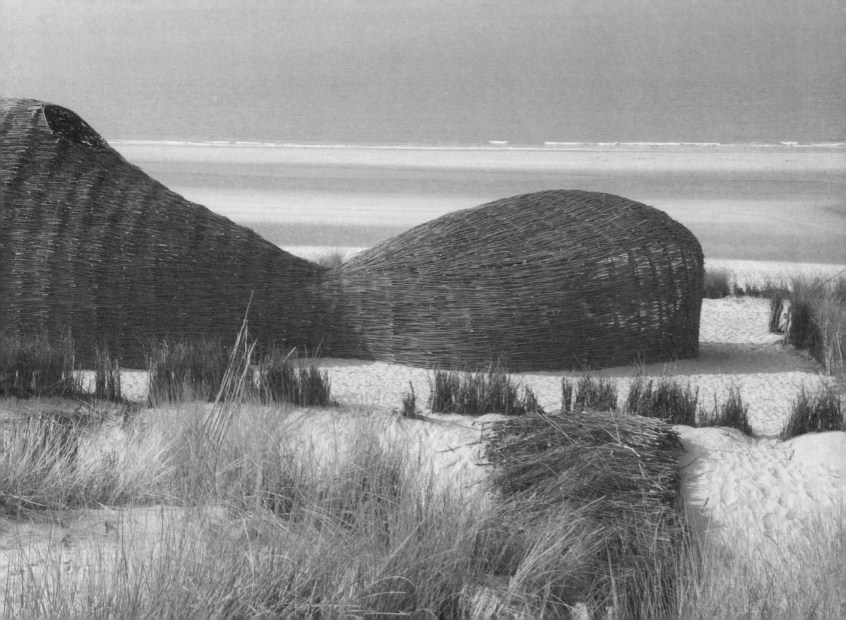

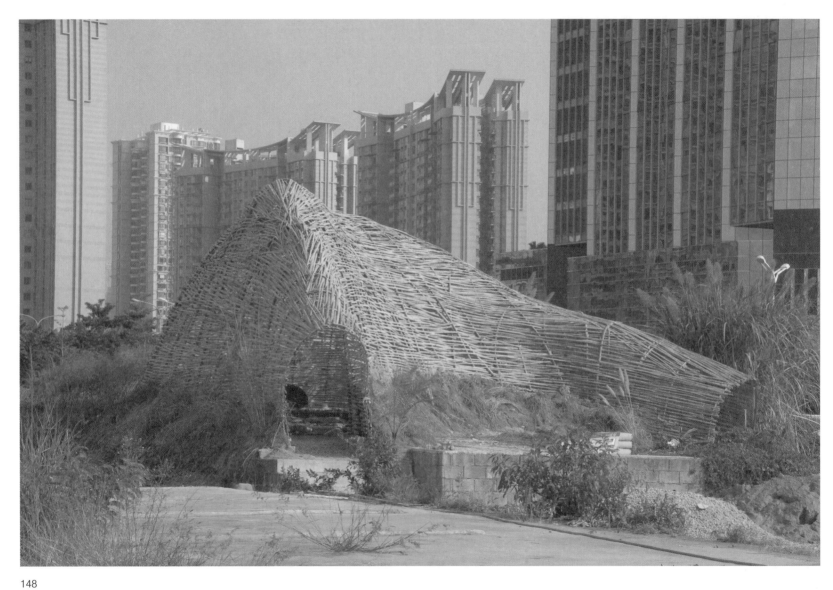

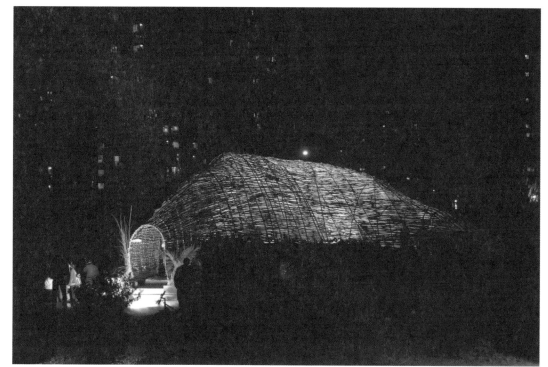

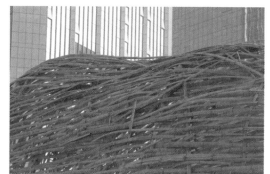

Bug Dome, SZHK Biennale (Shenzhen-Hong Kong Biennale of Urbanism/Architecture) Shenzhen, China, 2009

Built on a vacant lot amid the ruins of a demolished building, *Bug Dome* is located between Shenzhen City Hall and a camp occupied by migrant workers. The structure—both the underlying supports and the exterior—was made entirely of bamboo. This construction technique is typically used in the countryside in Guangxi, the native city of the workers camping in the area; they helped with the construction and shared traditional bamboo construction techniques with the artist.

Bug Dome is a shelter, a stage, and a hearth. During the Biennale it was used for concerts, poetry readings, and debates. When the Biennale ended, the *Bug Dome* remained acting as a meeting place where workers from rural areas could gather.

Bug Dome was created by Casagrande, Hsieh Ying-Chung, and Roan Ching-Yueh, who collectively call themselves WEAK!, taking their design cues from the natural world. The cocoon-shaped structure is meant to offer a place for respite from the rapidly expanding city of Shenzhen.

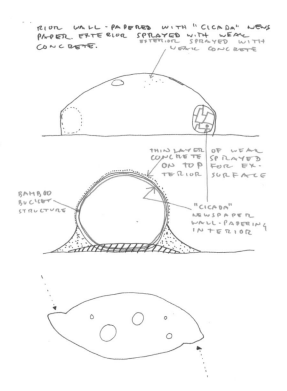

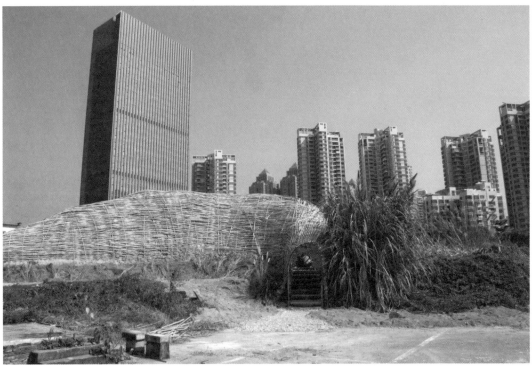

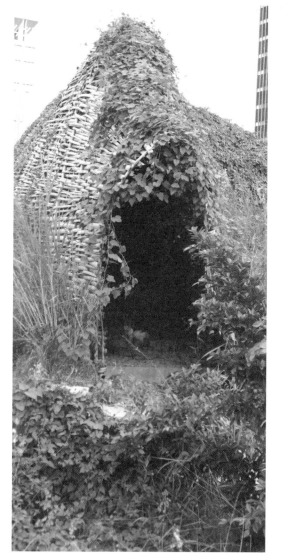

"Together we are the WEAK! Insects inspire our projects and construction methods."
—MC

Bug Dome is flexible, organic, and natural, a work of "weak architecture" whose construction relied on cooperation between designers and workers and an exchange of knowledge and traditions. The WEAK! team believes buildings should be designed and built with input from the places where they are located: a building should be a reaction to its environment rather than an attempt to cancel out reality.

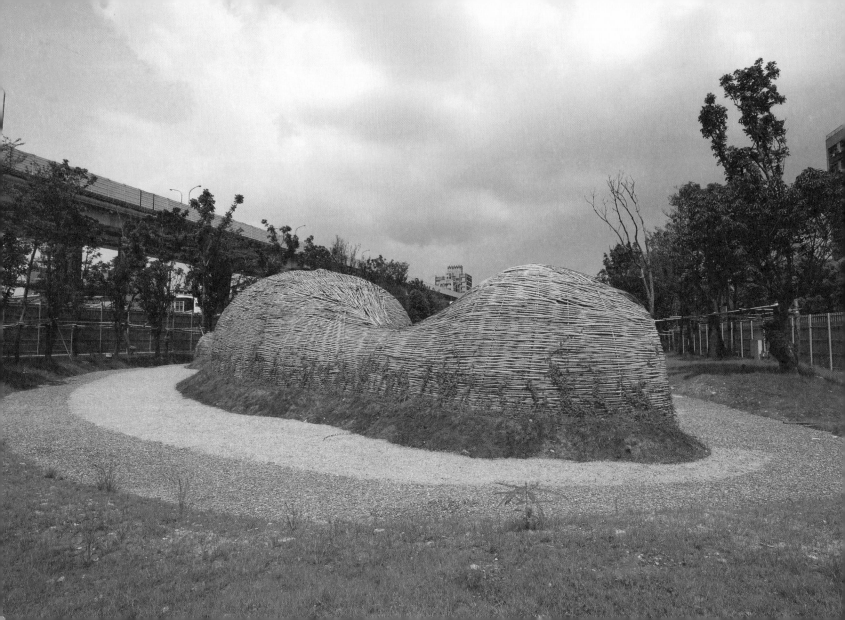

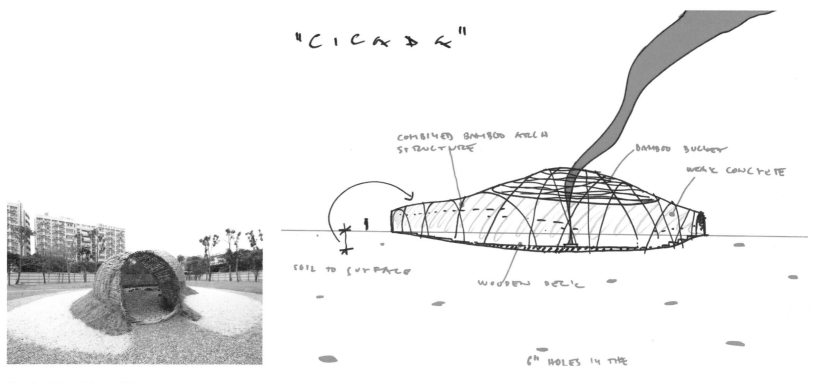

"CICADA"

COMBINED BAMBOO ARCH STRUCTURE

BAMBOO BUCKET

WEAK CONCRETE

SOIL TO SURFACE

WOODEN DECK

6" HOLES IN THE

Cicada, Taipei, Taiwan, 2011

Inside *Cicada*, the city disappears. This structure is shaped like a cocoon, and like a cocoon—soft and protected—it seems to breathe and vibrate. The internal space feels comfortable and inviting. The entire construction is made of woven bamboo—both the interior structure and the exterior. Designed as "urban acupuncture" for the city of Taipei, *Cicada* inserts itself into the industrial fabric around it by taking on an organic shape and by being accessible on a human scale. The structure is 111 feet (34 meters) long and sits in a small green space bordered by busy streets, railway lines, and densely built blocks. The surface underneath it is made of cast-off materials from the construction sites that dot the area.

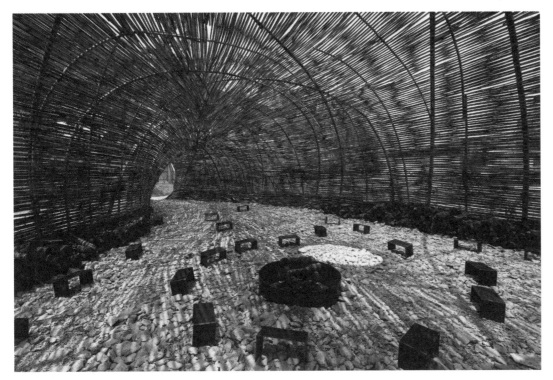

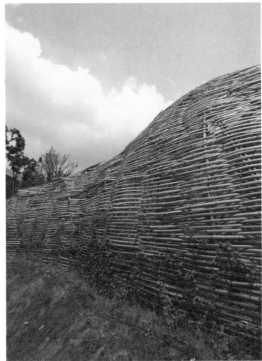

Cicada was designed as a gathering place and a social hub. Its inside is large and is centered around a fireplace located under the opening in the roof. A group of small chairs inside the installation can be moved, making for a flexible, loosely organized use of the interior.

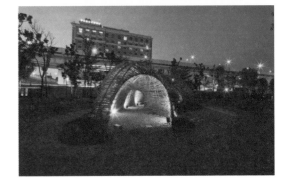

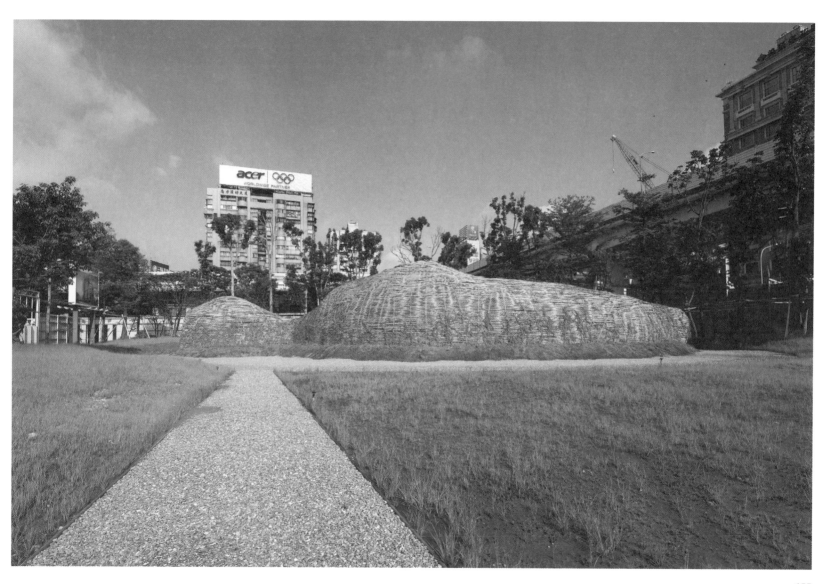

ROBERTO CONTE

*"My work is a long, slow walk where nature and my
hands are my companions and keep me company:
I can close my eyes (which also means opening
them) and listen together to their soul, allow things
to unfold and follow the invisible, discovering
how they grow and change; the rhythm of the
invisible is falling over me: discovering, discovering
myself; discovering yourself means removing
(taking from yourself) many things, with my hands
alone, and with nature."*
—RC

Teatro Naturale
Arte Sella, ArteNatura
Borgo Valsugana, Trentino, Italy, 2006

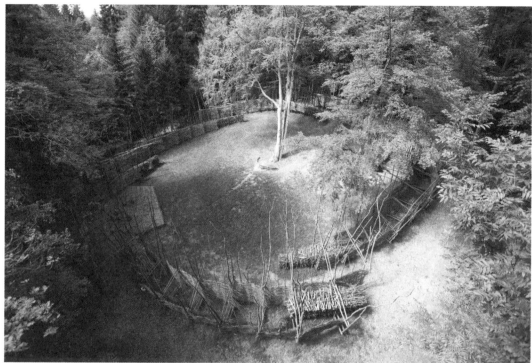

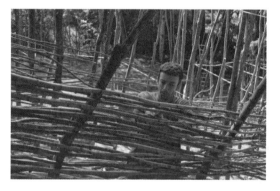

The structure is made of acacia and chestnut trees. The walls, modeled after support structures for trenches and fence embankments, are built from interlaced branches of hazelnut, laburnum, and flowering ash trees. The materials are from the surrounding woods—they were cleared as part of routine maintenance by traditional methods similar to those used on local farms in the surrounding countryside.

Teatro Naturale by the numbers:

• 4,000 hours of labor
• 400-person capacity
• 450 acacia and chestnut treetops
• 6,000 interlaced branches
• 820 feet (250 meters) of interlaced branches

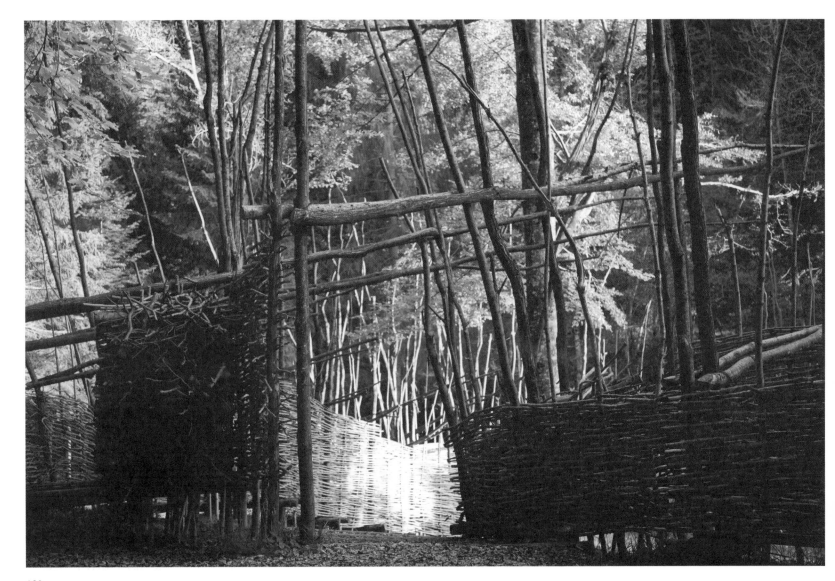

"This site in the woods was already a sort of theater in and of itself: the natural conditions were perfect for it. I wanted to maintain many things that were already in place, so I tried to listen to and incorporate the circular shape of the space, the group of four trees that grew together in the center, the weaving system used to build military trenches, the rotating motion generated by a small stream, and the verticality of the trees all around."
—RC

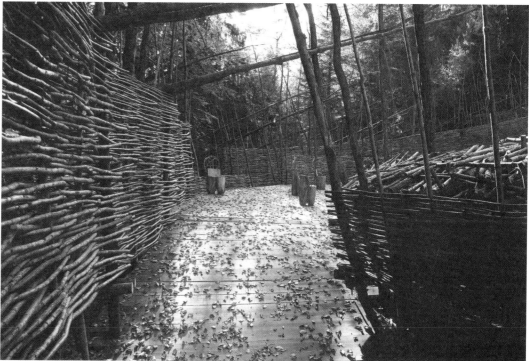

ALFIO BONANNO

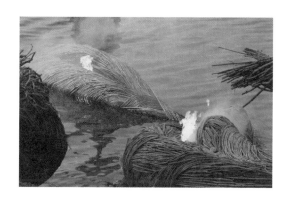

"Sculpture is like a physical space connecting
the human body with the environment. Because
I am a human I am connecting to other humans,
to my past, to my ancestors, to the land. There is
a thread connecting me to all of those things.
What could be more meaningful than to work with
those connections? The respect for the materials
is essential. I dialogue with the materials. If you
respect the materials, they will work with you."
—AB

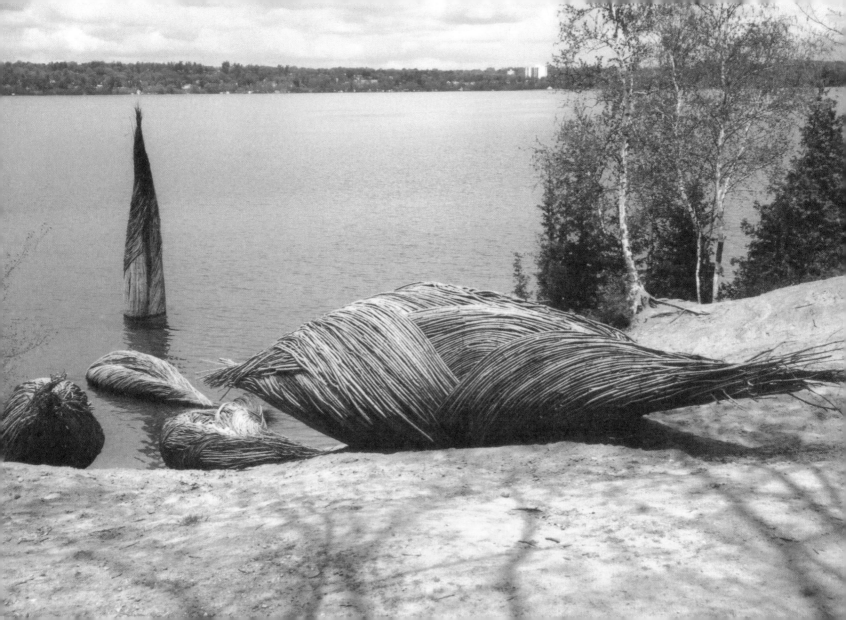

 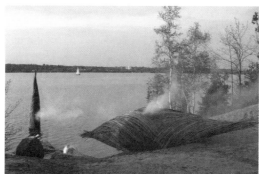 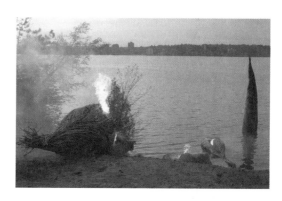

"Working on a site-specific project means studying, contemplating, learning, and cooperating. When I saw the shores of Lake Simcoe in Ontario, which surround the city of Barrie, and especially the beach in Kempenfelt Bay, I understood immediately that this would be the perfect spot: a place 'between land and sea.' I had to find a connection, an idea that could be identified with this place, something that would not make me feel like an intruder, but would stimulate dialogue with the place itself. I noticed that milkweed—a strong perennial plant with beautiful pods—was growing in the area. Their shape, two halves coming together with delicate seeds bursting out from the center, reminded me of the non-indigenous zebra mussels that pose an ecological threat to the lake and with that I had found the connection that I had been searching for. The monarch butterfly is dependent on the milkweed for the survival of its chrysalis. When we take this common plant for granted and we build our houses, shopping malls and roads on top of its natural habitat, we may carelessly cause the extinction of these butterflies. Nature has taken millions of years to achieve a very delicate balance; preserving that balance demands our care and attention."

—AB

PATRICK DOUGHERTY

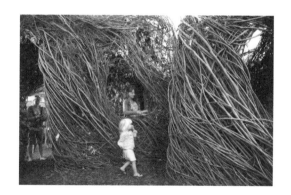

"Dougherty's works allude to nests, cocoons, hives, and lairs built by animals, as well as the man-made forms of huts, haystacks, and baskets created by interweaving branches and twigs together. Many of his works look 'found' rather than made, as if they were created by the natural force of a tornado sweeping across the landscape. He intentionally tries for this effortless effect, as if his creations just fell or grew up naturally in their settings."
—Linda Johnson, curator

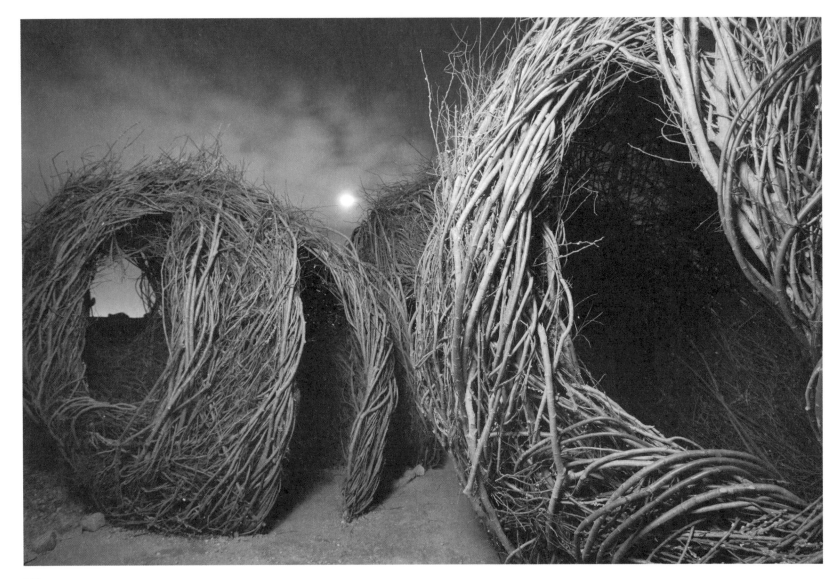

Childhood Dreams
Desert Botanical Garden, Phoenix, Arizona, 2007
Willow and poplar branches
39 x 25 x 16.5 feet (12 x 7.5 x 4.5 meters)

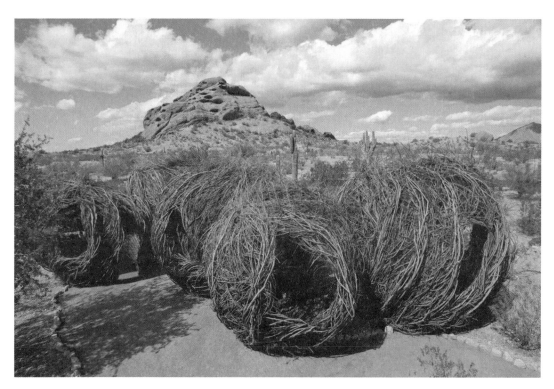

"In Childhood Dreams, I wanted to create a sculpture that was in harmony with the Desert Botanical Garden and the Papago Butte that sits behind it. The peace and beauty of the desert almost require reflection, and Childhood Dreams allows visitors to see the desert as if they're viewing it from inside a barrel cactus. Each portal in the sculpture reveals a different view of the desert's beauty."
—PD

On the Wild Side
Hui No'eau's Artist in Residence program
Makawao, Hawaii, 2011

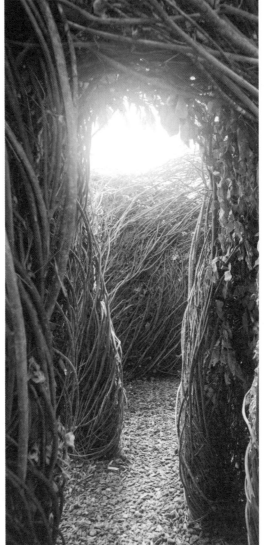

On the Wild Side launched Ho'ololi: The Environmental Art Garden, a new public art program. Ho'ololi's goal was to raise awareness of the plight of endangered Hawaiian ecosystems and encourage dialogue and public participation, as well as foster cooperation between artists and environmentalists.

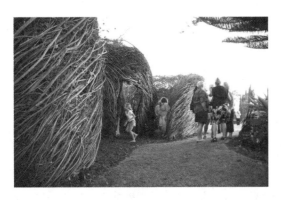

The primary material for the sculpture was branches from the strawberry guava plant, along with some eucalyptus and white ash. Strawberry guava was chosen with the input of the Maui Invasive Species Committee, which noted that this particular type of guava is one of the most invasive and damaging plants in Hawaii. Like many invasive plant species, strawberry guava grows in dense layers, crowding out cherished native plants, creating issues for both the forests and the watersheds of the Hawaiian Islands.

On the Wild Side will remain in place for three years.

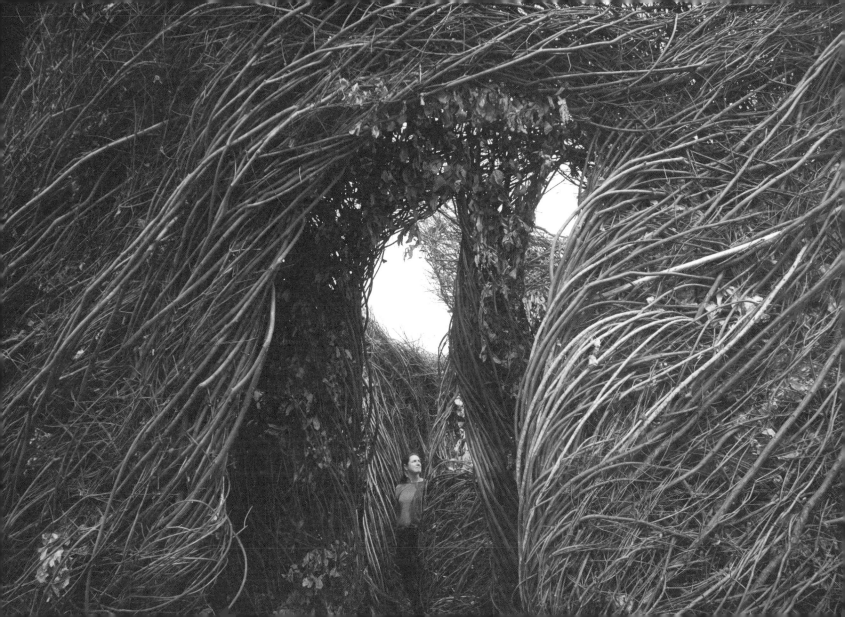

UENO MASAO

"I live in the countryside of Japan. I love the nature
that surrounds my house, including my bamboo
patches. I always find a theme for my work in my
daily life, so having a good relationship with
the nature and culture around me is key. They
are always my research subject."
—UM

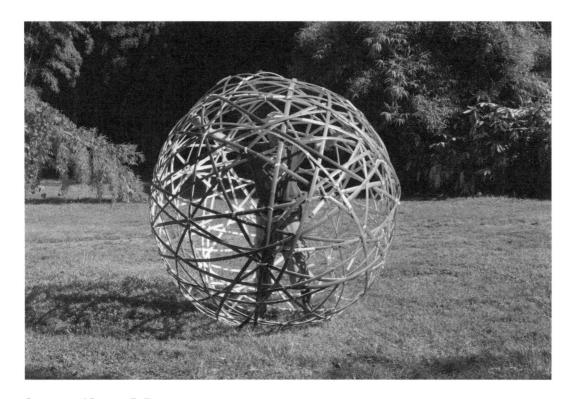

Cocoon and Dragon Ball
FITE Hs-Projets Hors Série installation with Bargoin Museum, Clermont-Ferrand Jardin Lucoq,
La Bambouseraie de Prafrance, Générargues
September 2012–March 2013

"*I worked as an architect for many years before I began working with bamboo. From 1980 to 1990, I visited many different Asian countries to meet with basket weavers. From southern China across the peninsula of Malaysia, to Indonesia and the Philippines, the craft of working with bamboo is still very popular. The villages are surrounded by bamboo forests. Children learn to work with bamboo to make toys. The residents of the villages are craftspeople who specialize in bamboo, and they know how important it is to keep an environmental balance between developing the forests and supplying raw materials. As an artist, I was profoundly influenced by their approach to nature and the environment that surrounds them.*"
—UM

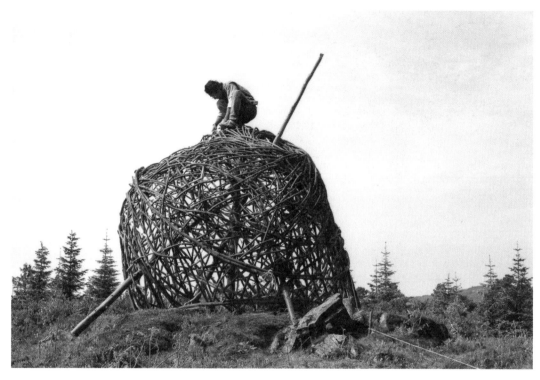

Axis of the Earth
England, June 1990
Woven pine branches, 13 x 13 x 10.8 feet (4 x 4 x 3.3 meters)

Ueno Masao's sculptures are site-specific. Materials are chosen and harvested on-site as well. For Grizedale, the artist wove pine branches together to create a large-scale plant skein that sits in a clearing. The resulting sculpture feels both alien and organic to the landscape.

Sculpture Festival in Snow
Yamanobe, Yamagata, Japan
February 2000
Bamboo, 32 x 6.5 x 6.5 feet (10 x 2 x 2 meters)

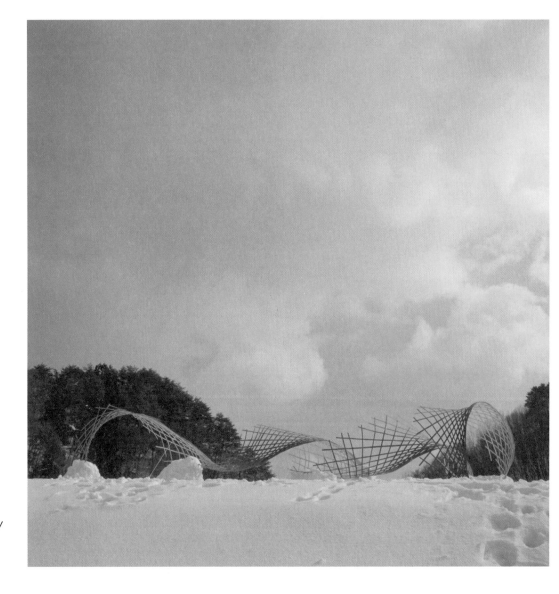

*"I always start by drawing a line on a piece of paper.
That becomes the basic concept for the volume.
Because a volume is made up of lines, the resulting
structure will let in light and air as if it were a woven
object. That results in surfaces that are simultaneously
fragile and closely connected to the surrounding
environment. That is my work."*
—UM

The artist's work for the museum in Sakura and the snow sculpture festival is light, transparent, and delicate. These installations seem to float above the ground. Their ethereal surfaces contort, and their shapes are so light that they become expressive. The artist used only bamboo, relying on its flexibility and resistance. The bamboo poles, each cut into two sections, were tied together with natural bamboo string to create a wholly new plant-based surface.

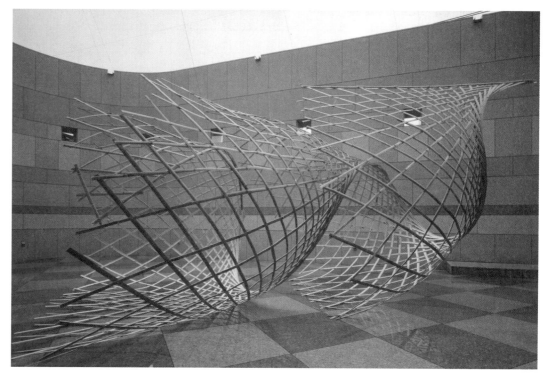

Sakura City Museum of Art
Sakura, Chiba, Japan, December 1996
Bamboo16 x 32 x 19.5 feet (5 x 10 x 6 meters)

DANIEL MCCORMICK

"I want these sculptures to have a part in influencing the ecological balance of compromised environments. I am compelled by the idea of using sculpture in a way that will allow the damaged areas of a watershed to reestablish itself. As it has evolved, my art has become focused on strategically congregating sculptural components made from riparian materials back into the watershed system. They are intended to give advantage to natural systems, and after a period of time, as the restoration process is established, they lose their identity as handmade objects."
—DM

Thicket
Los Altos, California, 2012

"My work seeks to move away from an anthropocentric point of view. Using a series of site-specific activities, this work initially gives aesthetic weight to the restoration process."
—DM

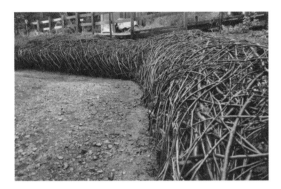 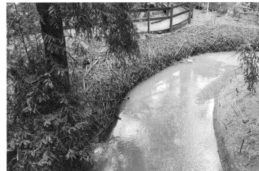 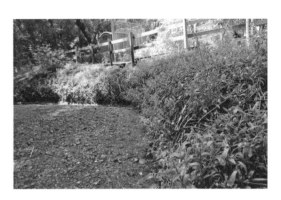

Thicket is an environmental sculpture that serves to fortify a watershed and help control the erosion of the banks of Adobe Creek in Los Altos. After the area was cleared of invasive plants, the structure was constructed from plant matter and other natural local materials. Branches, vines, and leaves were woven together to create a dense barrier that could resist the force of the water. *Thicket* follows the natural curve of the land and the riverbank and blends into the landscape. Over time, nature will reclaim the sculpture, absorbing it and giving it new life. The sculpture will become one with the surrounding landscape, and plants will grow over and around it, helping it to maintain its protective function. Daniel McCormick's environmental sculptures are generally designed for specific locations and to solve or offset specific issues.

Creek Revetment Wall
Corte Madera Creek, San Anselmo, California, 2005

For *Creek Revetment Wall*, the artist wove together red willow branches to create a very compact plant fabric that was used to cover and dam an area with thick plant growth on the banks of Corte Madera Creek. It's part of a larger project that aims to restore the creek and is focused on containing erosion of the banks during winter high-water periods.

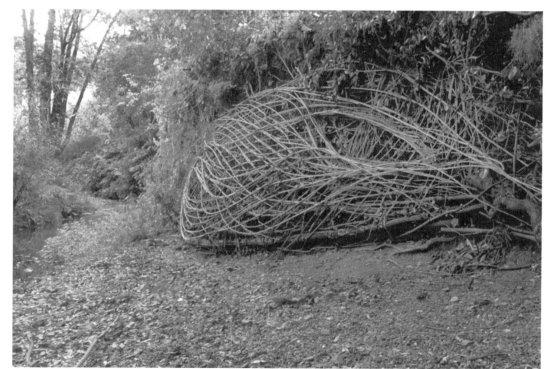

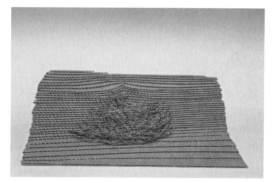

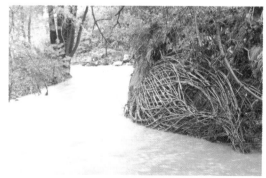

Intersections
Charlotte, North Carolina, 2009

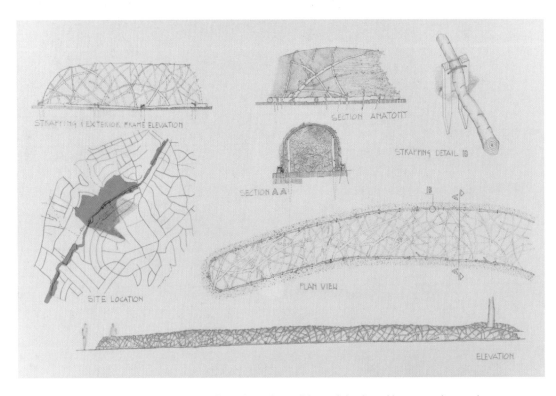

Intersections comprises three works that involve art, community, interdisciplinary cooperation, and the environmental and natural sciences. The goal of *Intersections* is to offset and lessen the water runoff that urban development has caused in the Charlotte area. The installation serves as a barrier wall that controls the release of water from the surrounding natural wetlands. *Intersections* is constructed from a layer of plant life covered with a coconut fiber mat and another layer made of willow, dogwood, and elder branches, all shaped and compressed together.

"Beyond trying to lend credence to different methodologies, I try to bring attention to these restoration efforts through tangible participation with community members. My process is formed on the principle that through collaboration one can create public art that encourages sustainability and stewardship of the environment. It has been my experience, once I have become engaged in this kind of conservation effort, that the issues become reframed and the community is encouraged to participate. My past work has civic decision-making and ongoing engagements with scientists and conservation groups and the community at large."
—DM

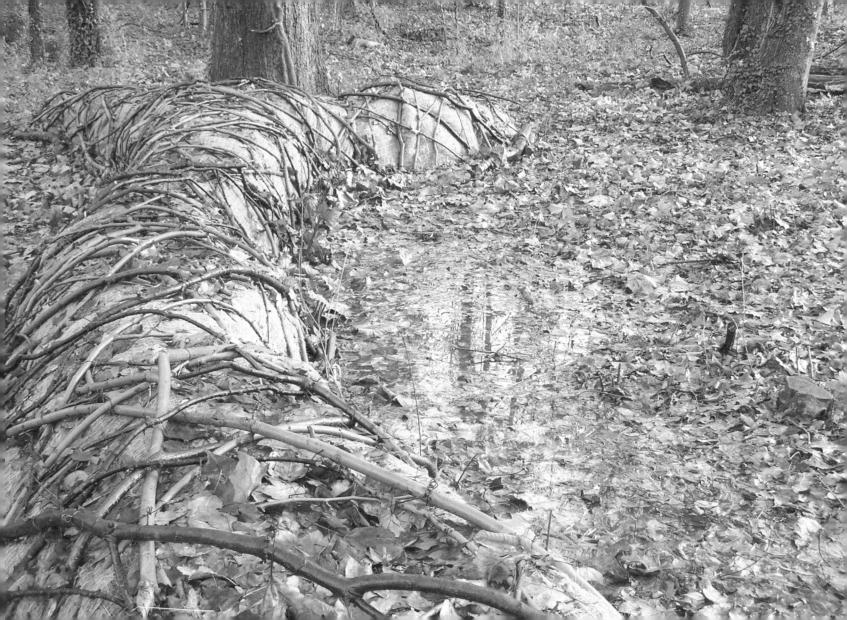

RINTALA EGGERTSSON with PAOLO MESTRINER and MASSIMILIANO SPADONI

This landscape project touches on concepts of
ecology, the environment, and sustainability
and through related tools attempts to create a space
to interact with the area physically.

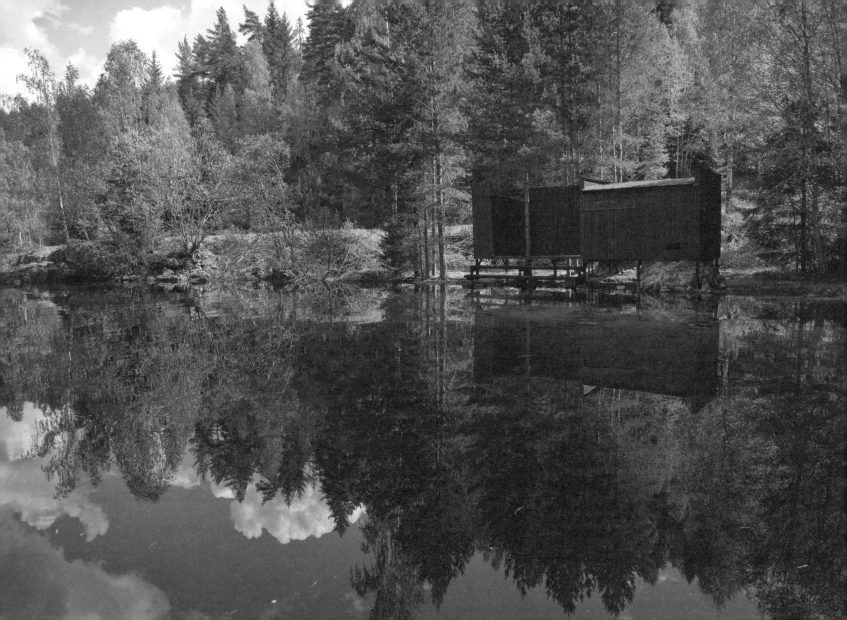

Into the Landscape
International construction workshop
Seljord, Norway, September–October 2009
Client: Seljord Municipality
Workshop management: Rintala Eggertsson Architects
Teachers: Sami Rintala, Dagur Eggertsson, Paolo Mestriner studioazero, Massimiliano Spadoni architect, Luca Poncellini
—
Coordination: NABA Milan, Polytechnic University of Milan, Municipality of Seljord, Norwegian Theatre Academy Østfold University
Project management: Springer Kulturstudio and Feste Grenland

 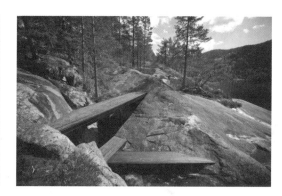

From September 25 to October 3, 2009, a group of students in the master's program in interior design at NABA, the academy of art and design in Milan); the master's program in extraordinary landscapes at NABA and the Polytechnic University of Milan; and the Fredrikstad Scenography School designed and built three structures near Seljord Lake in the Telemark region of southern Norway.

The workshop was overseen by Rintala Eggertsson Architects, with the assistance of Paolo Mestriner, Luca Poncellini, and Massimiliano Spadoni.

Three structures—a viewing point, a sauna, and a fishing point—were designed as spaces for tourists and residents to rest and gather together.

The buildings were constructed in eight days, largely of wood. Stones collected on-site were used for the foundations.

The Into the Landscape workshop was part of the larger "Seljord and Sågene" project coordinated by Springer Kulturstudio and Feste Grenland that aims to revitalize the local economy and attract tourism.

The sauna was built on a rocky shore on the southern edge of the lake. The small, wooden structure is painted black and it rests atop posts so that it won't be impacted by rising water levels in the lake. The simple construction consists of a sauna room with a stove and a terrace that faces the lake.

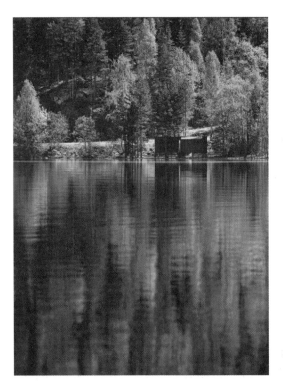
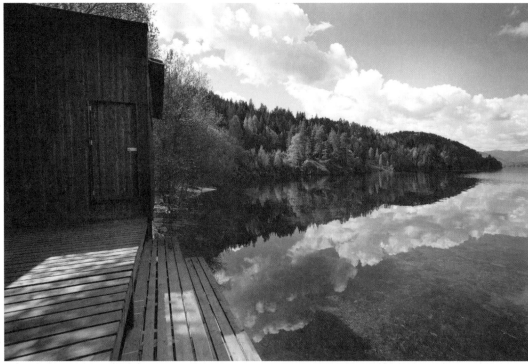

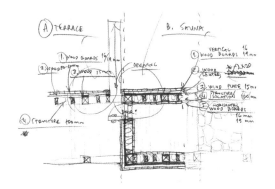

This structure serves as a barrier from the bordering road and keeps the lake area better protected. The road is accessible via a ramp that winds between trees in the woods surrounding the construction. The sauna still functions and is beloved by local residents, who had eagerly followed the progress of the workshop and the construction. The viewing point observatory is located atop a hill on the north side of Seljord Lake and offers a panoramic view of the lake and the valley.

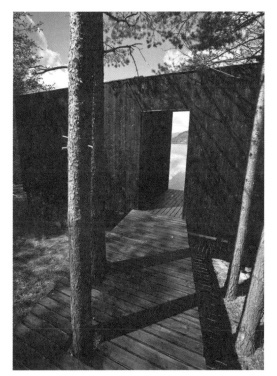

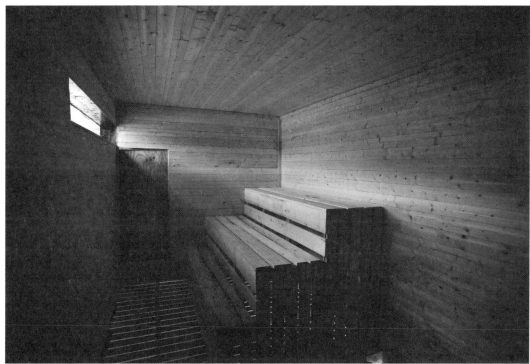

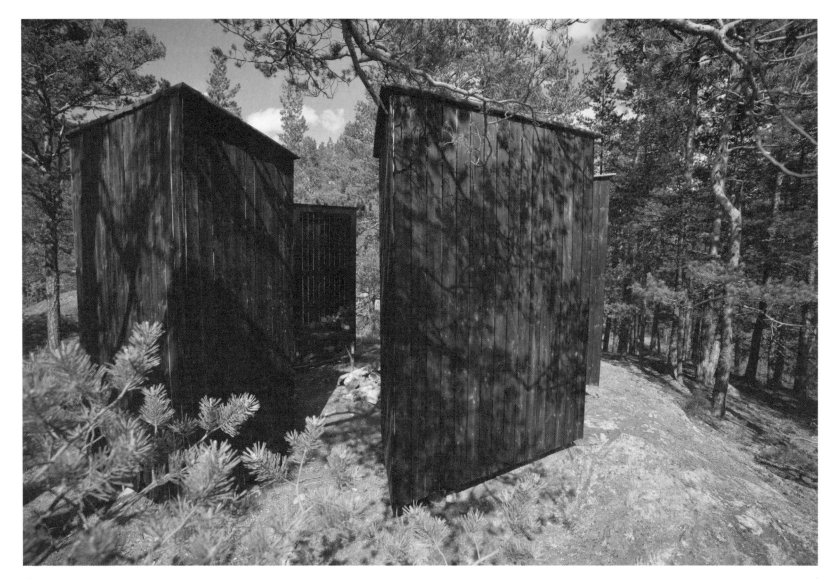

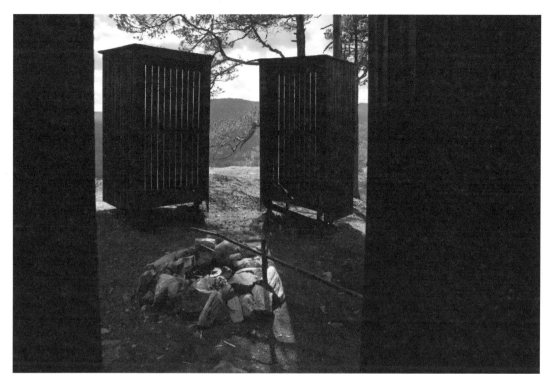

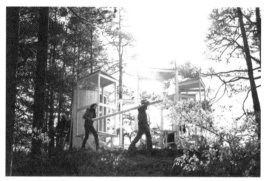

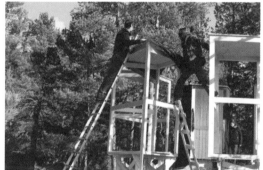

The six rooms are arranged in a circle, with a fireplace in the center. Each room serves as a shelter for one to two people at most, but the layout allows a group of visitors to gather together around the fire. Utilizing the same architectural and stylistic language as the sauna, the observatory buildings are wooden and have been painted black. They are anchored to the underlying rock with steel.

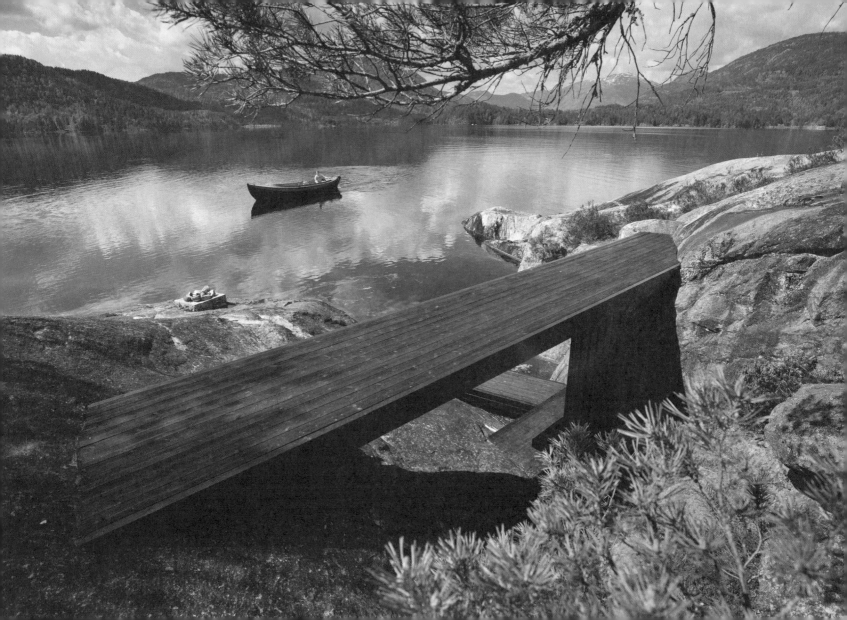

The fishing point sits at the end of the Tellness Peninsula, which reaches into the center of the lake. This installation is located in a rocky hollow and is gently integrated with the shape of the rock and the landscape as a whole. There has long been a legend that says a sea serpent lives in the waters of Seljord, and fishermen and local residents report frequent sightings.

The structure itself serves a dual function: it is a pedestrian bridge and also a shelter where fishermen can rest and light a fire.

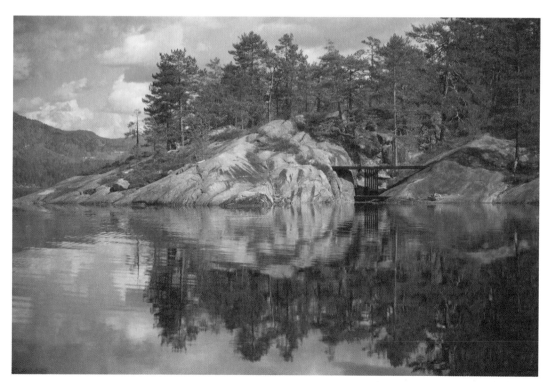

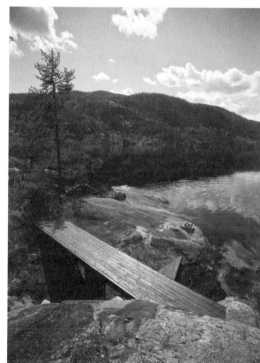

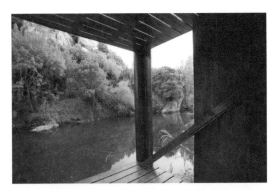

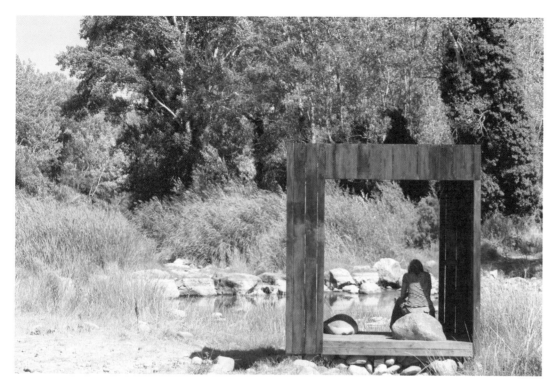

ECORURALITY 2011: LAND H2O!
International construction workshop
Allai, Province of Oristano, Sardinia, Italy, June 2011
—
Client: Municipality of Allai and Associazione
Paesaggi Connessi
Project managers: Paolo Mestriner studioazero,
Massimiliano Spadoni architect, Rintala Eggertsson
Architects, Luca Poncellini
Teachers: Dagur Eggertsson, Paolo Mestriner,
Massimiliano Spadoni, Luca Poncellini, Davide Gamba,
Luca Molinari
Coordination: NABA Milan, Polytechnic University of
Milan, Municipality of Allai, Associazione Paesaggi
Connessi, Carlo Salvatore III Laconi

The LAND H2O! workshop worked on a 1:1 scale to create work that would have a concrete connection to the landscape surrounding it.

Learning about the municipality of Allai and using wood construction techniques made this project an engrossing experience for the participants.

Indeed, the landscape itself became an important part of the installation. It helped create a conversation between architecture and nature in a dialectical, open, and sensitive manner. Additionally, international students dialogued with the local community so that they not only created architecture, but also learned about the landscape and the site.

The third annual edition of the Ecorurality program, which launched in the municipality of Allai in 2009, was organized by the Associazione Paesaggi Connessi working with the municipality of Allai, and was implemented with the assistance of the international master's program in extraordinary landscapes and the master's program in interior design at NABA Milan and the Polytechnic University of Milan. This design workshop was intended to offer wide-ranging knowledge of the landscape and the area, including its culture. During the workshop, two minimalist works were created: a wharf for riverboats to dock and a viewing point and information kiosk.

MIILU

XI Architecture Biennale, Biennale Gardens
Venice, November 2010

—

Client: Swedish Museum of Architecture,
Norway's Museum of Art, Architecture, and
Design, and the Museum of Finnish Architecture
Curators: Karin Äberg Wærn, Eva Madshus,
Kristiina Nivari, Anders Johanson/Testbedstudio
and Tor Lindstad/Economy
Workshop management: Rintala-Eggertsson Architects

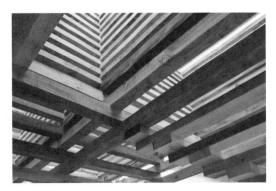 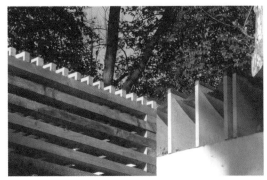

Architecture students from the Norwegian University of Science and Technology in Trondheim and the Polytechnic University of Milan collaborated to build a small wooden structure in front of the Nordic Countries Pavilion over the course of five days. The project was based on available materials, the characteristics of the chosen wood, the building site, and the manual skills of the participants. Rintala Eggertsson's method for dealing with environmental conditions and other challenges that arose during the process was to see them as opportunities that would help the project evolve further and enhance the cultural and professional knowledge of the participants.

The result was that a simple idea took concrete form. The word *Miilu* is ancient Finnish for a wooden pile used to produce tar. This *Miilu* is intended to serve as an informal meeting space for visitors to the Biennale. The structure is made of pieces of timber of different sizes that are joined together in geometric form so that they resemble a group of sticks dropped for a game of pick-up sticks. *Miilu* is 172 square feet (16 square meters) in size. It sits on a 13-by-13-foot (4-by-4-meter) base, and it is 13 feet (4 meters) tall. Approximately 217½ cubic feet (6.16 cubic meters) of wood were used in its construction.

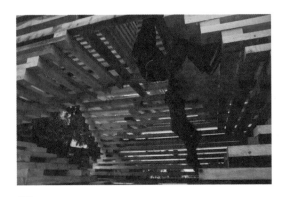 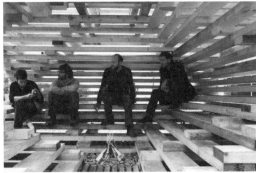 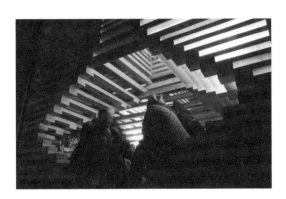

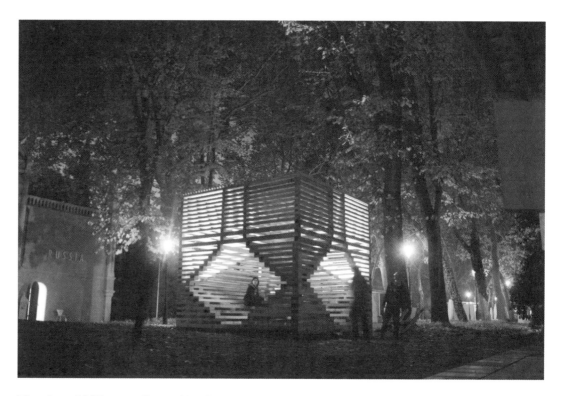

The size of *Miilu* was dictated by the technique used and the underlying aesthetic principles of the design team—yet its scope also works as a means of expression, and it is an elegant partner to the Nordic Pavilion, which was designed by Sverre Fehn in 1958. The play of light and shadow inside *Miilu* is an homage to both the vibrations of light that typically occur across the facades of the Venetian buildings that line the Grand Canal and the poetic quality of the ceiling of Fehn's pavilion. It evokes the idea of continuity and ambiguity between external and internal spaces.

At night the structure is lit from within and is transformed into a sort of lantern that fills the viewer with a sense of enchantment.

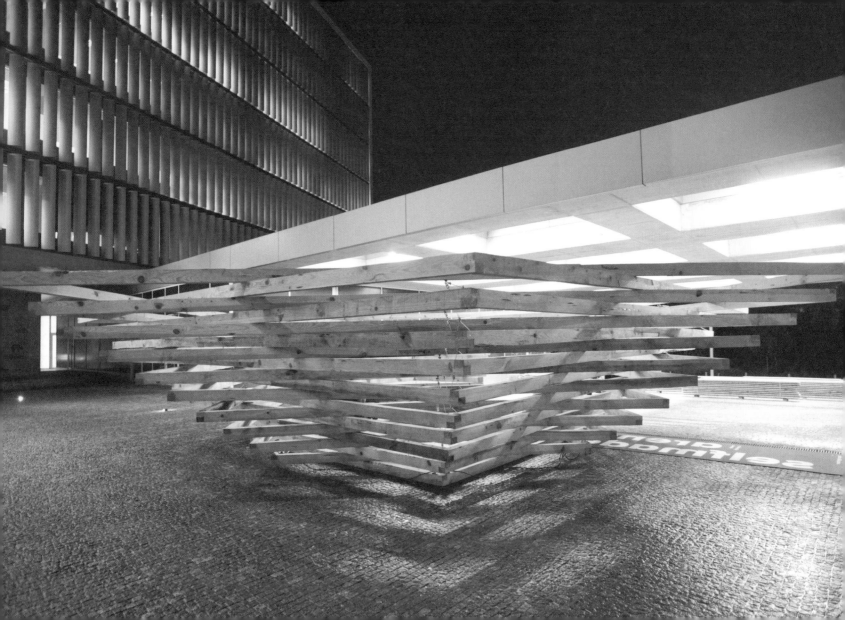

Arena Selfmade
International construction workshop
Porto, Portugal, November 2012
—
Project managers: Rintala Eggertsson Architects, Paolo
Mestriner studioazero, Massimiliano Spadoni architect
Instructors: Maria Milano, Dirk Loyens, João Cruz,
Joana Santos, Josè Castro, Paulo Pereira, Paulo Seco,
Rafael Coelho, Vitor Varão

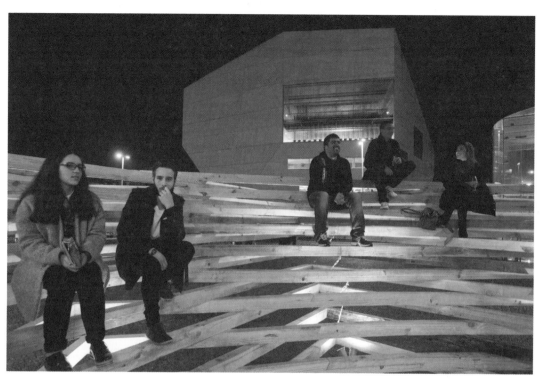

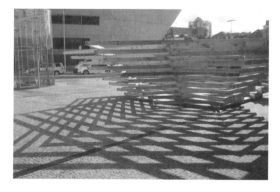

Fundação EDP and Remade in Portugal invited architects Sami Rintala, Dagur Eggertsson, Paolo Mestriner (studioazero), and Massimiliano Spadoni with Esad, the art and design high school in Matosinhos, and Design Factory to organize and conduct the Arena Selfmade workshop from October 27 to November 10, 2012. The workshop's goal was to construct a space for meetings/conferences in front of the EDP gallery in Porto near the House of Music. The resulting structure—the Arena Selfmade—is open to anyone passing through the surrounding public space. The arena is intended to be useable and open, but it is also contained inside a semitransparent barrier. The small arena was designed to be used by participants in all different kinds of conferences and also act as a concrete example of the "Remade in Portugal" theme of reuse and sustainability.

LEGENDRE-PERON

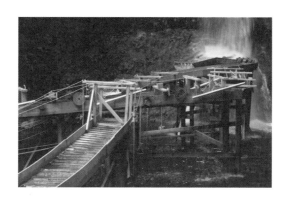

Coup de coeur du public! *DesAccords de Nature* was the audience favorite at Horizons: Arts Nature in Sancy, France. *DesAccords de Nature* is a technically complex and precise, but also strongly imaginative work. It encourages viewers to reflect on current environmental issues both through the materials used to construct it and by its direct interaction with nature.

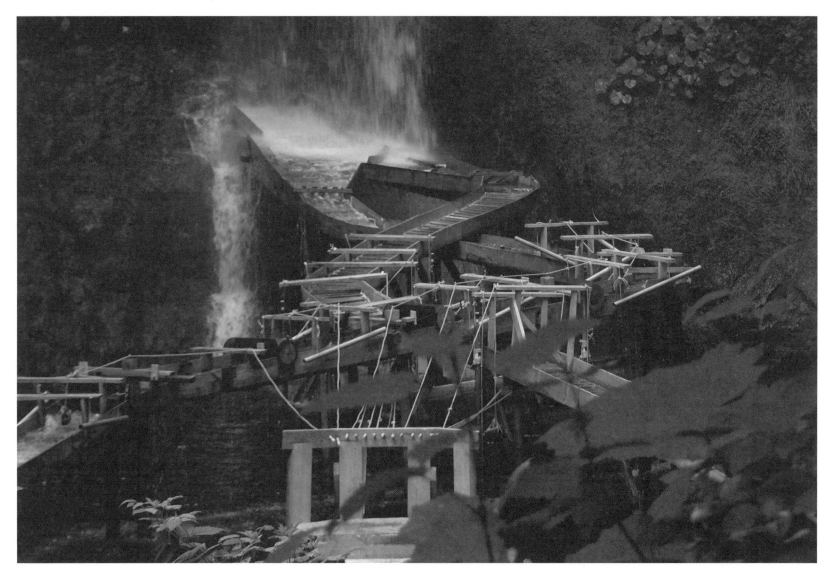

DesAccords de Nature

Horizons: Arts Nature, 2011
Entraigues Waterfall, Egliseneuve d'Entraigues, Massif de Sancy, France, 2011
Wood and rope sound installation
23 x 82 feet, 11.5 feet high (7 x 25 meters, 3.5 meters high)

This project from the duo of Legendre-Peron relies on a multidisciplinary approach: ethnobotany, molecular biology, ecology, art, and architecture are all integral to its construction.

The idea for the 2011 edition of Horizons: Arts Nature was to create work that would interact with people and nature through the use of sound. *DesAccords de Nature* reflects on the essence of nature and current ecological and environmental issues. The piece is made completely of wood and rope and enjoys a deep connection to its surroundings. Simply put, it connects man and nature. For the shape, the artists drew inspiration from a string of human DNA, the molecular sequence that defines a person's identity.

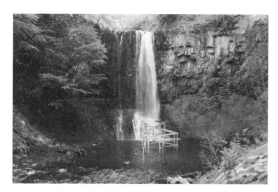 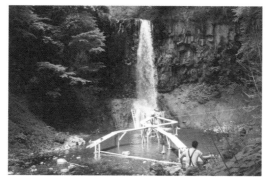 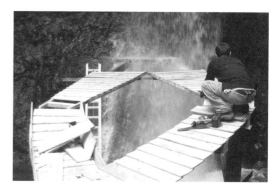

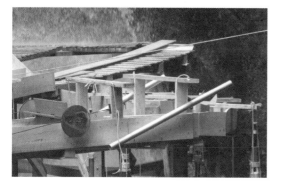 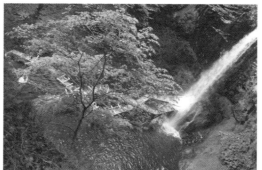

The installation invites visitors to listen to the sounds of the waterfall and water in motion. They can also interact with the rope mechanism. Indeed, *DesAccords de Nature* is like a giant musical instrument that modifies the sounds of the water and the falls, creating new types of interaction between people and nature.

ICHI IKEDA

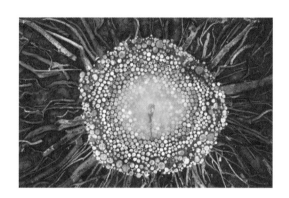

"We as people have to understand why water, which is so full of life, is our means for changing borders, customs, stories, cultures—our means for defining a deep-rooted change among human beings."
—II

Water in Water
Moving Water Days 2007 for spreading
ecological action
Kedogawa River Art Project Makurazaki,
Kagoshima, Japan, 2007

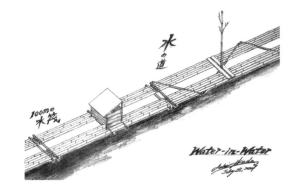

The goal of Moving Water Days 2007 was to
embrace society's potential to connect daily
life to nature.

On September 28th, the bamboo rafts,
which were up to 325 feet (100 meters) long,
began to move toward the East China Sea.
The fleet of rafts was rowed down the river,
bearing a message about an environmentally
sustainable future.

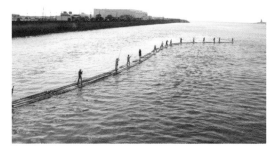

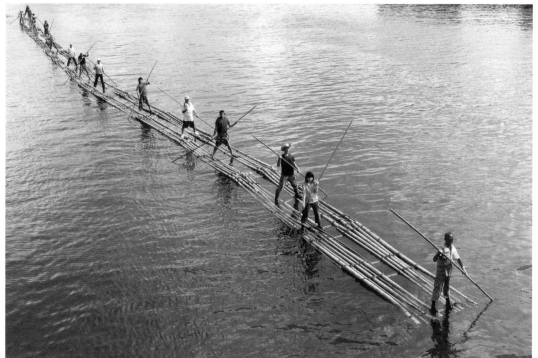

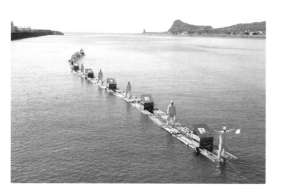

On September 29, students from the Kagoshima school of fisheries flew flags with the message "SAVE WATER" printed on it.

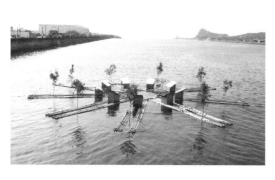

On September 30, the bamboo rafts were turned into what was deemed a "water village." This entailed loading small bamboo and oak huts onto the rafts.

"Initially we sought out a bamboo forest that needed cutting to get the materials for the installations. We worked with the school of fisheries in Kagoshima to construct rafts with the bamboo poles. After a month's worth of work we brought the rafts to the Kedogawa River."
—II

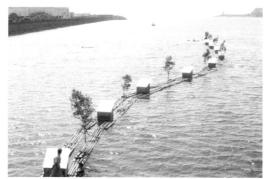

Onward to the East China Sea.

L-shaped Walks of Peace
GENESIS, Japan, August–September 2011

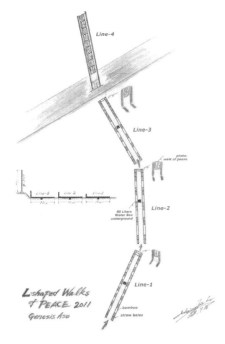

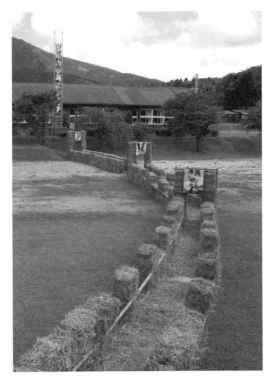

The installation consists of two structures:
a horizontal line made by piling up bales of
hay, and a vertical element, also made
of hay, hung with images of legs in water.

Following the Fukushima nuclear disaster in spring of 2011, more than fifty families in the Aso area were forced to relocate in order to avoid potential radiation contamination. This installation was a response to the calamity.

"GENESIS was held in the Aso area, located near a large volcano, and I participated in it. My inspiration was the area itself, the feeling of being connected to the earth and with the 'earth under your feet.' Behind the elementary school is the large Neco volcano, now inactive, and it was here that I began to work with residents of the area to install L-shaped Walks of Peace in the schoolyard. Many residents who worked with me on the construction had moved from the Kanto region. We worked to create hope for a new future, 'not the future for art, but art for the future.'"
—II

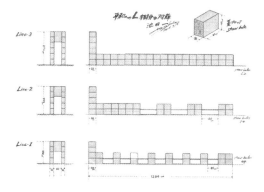

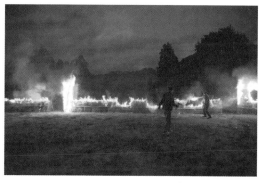
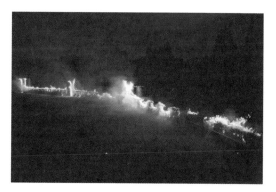

When the exhibit came to an end, the entire installation was burned to exorcise and expel the fears evoked by the Fukushima disaster.

BALL-NOGUES STUDIO

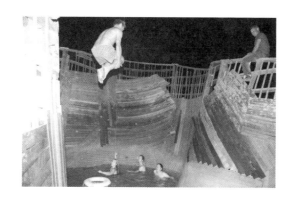

"*This approach integrates concept, aesthetics, social relationships, and production, inviting viewers to reconsider their relationship to art by-products while repositioning them within an alternative economic and geographic domain.*"
—B-N

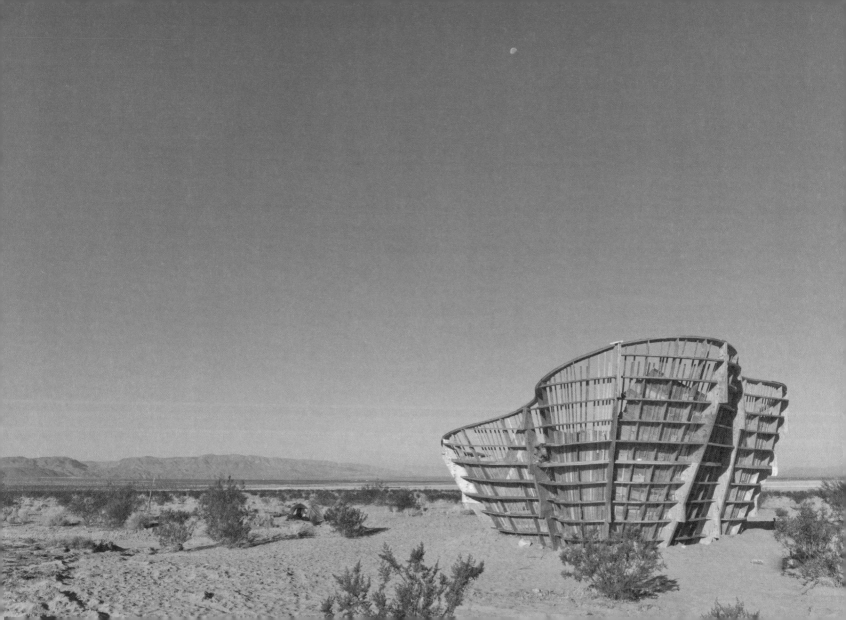

Yucca Crater
Near Joshua Tree National Park, California, 2011

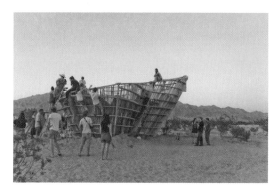 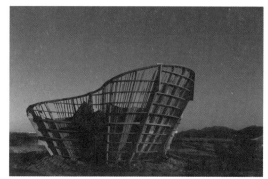 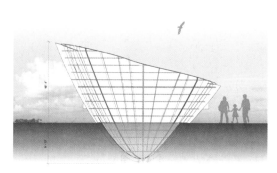

Located in the desert near Joshua Tree National Park in California, fifteen miles from the nearest human settlement, *Yucca Crater* is a temporary installation created by the Los Angeles–based Ball-Nogues Studio as part of the High Desert Test Sites event that was held in October of 2011.

High Desert Test Sites generates physical and conceptual spaces to explore the intersections between contemporary art, people, the landscape, and life in general. After the event, *Yucca Crater* was abandoned to the forces of nature and the desert landscape. *Yucca Crater*'s playful design featured a wooden structure that formed a water-filled basin. The structure was almost 16½ feet (5 meters) tall and was sunk more than 10 feet (3 meters) into the ground. Visitors could climb up onto the edge and descend to bathe in its saltwater pool.

Yucca Crater expands on concepts borrowed from land art, echoing the landscape of abandoned suburban swimming pools and ramshackle dwellings scattered across the Mojave. Ball-Nogues reimagined these elements of the landscape by producing an object that was physically inserted into the ground and therefore could not help but become part of the landscape.

BIBLIOGRAPHY

Carugati, Decio Giulio Riccardo. *Giuliano Mauri*. Milan: Mondadori Electa, 2003.

D'Angelo, Paolo. *Estetica della natura. Bellezza naturale, paesaggio, arte ambientale*. Rome and Bari, Italy: Editori Laterza, 2010.

Dougherty, Patrick. *Stickwork*. New York: Princeton Architectural Press, 2010.

Fagone, Vittorio, ed. *Art in Nature*. Milan: Mazzotta, 1996.

Fagone, Vittorio. *Giuliano Mauri: Arte nella natura 1981–1993*. Milan: Mazzotta, 1993.

Garraud, Colette. *Idée de nature dans l'art contemporaine*. Paris: Flammarion, 1994.

Giovannini, Wanda, and Laura Tomaselli. *Arte Sella 2004*. Rovereto, Italy: Nicolodi, 2005.

Grande, John K. *Art Nature Dialogues: Interviews with Environmental Artists*. Albany: State University of New York Press, 2004.

Kassner, Lily. *Yolanda Gutiérrez: El arte de divinizar la naturaleza*. Mexico City: Consejo Nacional para la Cultura y las Artes, 2007.

Kastner, Jeffrey, and Brian Wallis, eds. *Land and Environmental Art*. London: Phaidon, 1998.

May, John, and Anthony Reid. *Architettura senza architetti*. Guida alle costruzioni spontanee di tutto il mondo. Milan: Rizzoli, 2010.

Mestriner, Paolo, and Giorgio Azzoni. *Abitare minimo nelle Alpi*. Syracuse, Italy: Lettera Ventidue Edizioni, 2013.

Montibeller, Emanuele, and Laura Tomaselli. *The Contemporary Mountain*. Cinisello Balsamo, Italy: Silvana Editoriale, 2009.

Quinze, Arne, and Saskia de Coster. *My Secret Garden & Rock Strangers*. Amsterdam: Frame Publishers, 2013.

Somfist, Alan, ed. *Art in the Land: A Critical Anthology of Environmental Art*. New York: Dutton, 1983.

Tiberghien, Gilles A., ed. *Land Art*. Paris: Édition Carré, 1995.

Tiberghien, Gilles A. *Nature, art, paysage*. Arles, France: Actes Sud, 2001.

THE ARTISTS

AL BORDE is an architecture and research studio involved with social issues and solutions to real-life problems. The group works with materials and resources available on-site, beginning with preexisting materials, and recombining them as needed. Its work in the field is complex, but also holistic and interdisciplinary. Al Borde projects are notable for their ability to combine architecture with the subjective needs of the end user through hybrid construction systems that unite traditional techniques with modern-day planning. The firm was founded in Quito, Ecuador in 2007 and consists of David Barragán, Pascual Gangotena, Marialuisa Borja, and Esteban Benavides. Al Borde also conducts workshops and courses at many international universities and has received a number of awards.
www.albordearq.com

ANTS OF THE PRAIRIE is an architecture and research studio devoted to the development of creative approaches to dealing with environmental and ecological issues. Ants of the Prairie creates what it calls works of "pest architecture." Joyce Hwang, who leads the firm, earned a master's in architecture at Princeton University and a bachelor's degree in architecture from Cornell University, where she was awarded the Charles Goodwin Sands Memorial Bronze Medal. Since 1997 she has worked in San Francisco, New York, Philadelphia, and Barcelona. She is currently an assistant professor of architecture at the University of Buffalo.
www.antsoftheprairie.com

BALL-NOGUES STUDIO Benjamin Ball grew up in Colorado and Iowa. He studied architecture in California and after graduation began to work as a set and production designerin the film industry. Ball works with Gaston Nogues to explore the connections and relationships between architecture, art, and product design by using both plastic and digital modeling. Nogues was born in Buenos Aires, but moved to Los Angeles when he was 12. Always interested in construction processes and techniques, he studied architecture and began his career at Frank Gehry's firm, where he worked as a product designer specializing in creative fabrication. Working with Ball, Nogues handles creation and construction.
www.ball-nogues.com

ALFIO BONANNO was born in Milo, Sicily, in 1947. In the early 1950s his family immigrated to Australia, where Bonanno studied painting. In 1965 he returned to Italy. After working in Rome for six years, Bonanno moved to the Island of Langeland in Denmark. A pioneer in the field of environmental art and a representative of the European development of land art, or "art in nature," Bonanno creates site-specific installations in outdoor environments. Symbiosis between art, nature, and ecology is a key aspect of his work.
www.alfiobonanno.dk

MARCO CASAGRANDE was born in Turku, Finland, in 1971. He graduated from the University of Helsinki in 2001 and early in his career began attempting to combine architecture with other artistic and scientific disciplines, working with architectural-artistic installations on the theme of ecology and the environment. Casagrande's work invokes architecture, urban planning, art, environmental design, and environmental sciences, and combines them with an awareness that "there is no other reality than nature." Since 2000 Casagrande has taught at several different universities.
www.marcocasagrande.fi

ROBERTO CONTE is a self-defined "builder in nature." An architect by training, he works by listening to what nature has to offer and following his senses to discover possibilities for expression and act as an artist both of and in the landscape. Over the years he has worked frequently with Arte Sella, where he has been involved in education and graphics and has headed up several events. As part of the ArteNatura walking project, he created several works, including Teatro Naturale, which appears in this book.
www.robertoconte.eu

PATRICK DOUGHERTY, gifted with both carpentry skills and a love of nature, has studied primitive building techniques and uses tree saplings as his primary construction material. In 1982 his first work, Maple Body Wrap, was included in the North Carolina Biennial Artists' Exhibition. The following year he had his first one-person show at the Southeastern Center for Contemporary Art in Winston-Salem, North Carolina. His methods quickly evolved, and he transitioned from single pieces on pedestals to large-scale environmental works—true buildings—made with large quantities of plant materials.
www.stickwork.net

YOLANDA GUTIÉRREZ was born in Mexico City in 1970. She currently lives and works in Atlixco, Puebla. She holds a degree from the National School of the Arts, and from 1992 to 1995 was an assistant professor in the Visual Experimentation II laboratory at the National School of the Arts.
www.yolandagutierrez.org

PORKY HEFER DESIGN is headed by Porky Hefer, who worked as a creative director at various advertising agencies for 14 years. In 2007 he founded Animal Farm, a creative consulting company. In 2011 he founded Porky Hefer Design, which focuses on design and product design with natural themes and the recovery and recycling of construction materials. Over the years he has won a number of awards and is widely recognized for his work as a designer and creative.
www.animal-farm.co.za

ICHI IKEDA was born in Osaka, Japan in 1943. He has always had a strong interest in global environmental issues, especially those involving water. Ikeda uses water as his chief means for construction and expression, exploring the potential of this seemingly uncontrollable substance. Since 1997 he has been working on a project titled World Water Ekiden in the belief that any location can become a place to promote "the water of the future" for later generations. His art is a catalyst for those working toward change and a source of inspiration for the exchange of information about water conservation issues.
www.ikedawater.org

KADARIK TÜÜR ARHITEKTID is an Estonian architecture firm with offices in Tallin that focuses on planning and design. The firm handles urban planning, the design of public and private buildings, interiors, and design. The founders of the firm are Ott Kadarik and Mihkel Tüür, both born in 1976.
www.kta.ee

LEGENDRE-PERON is two young French artists. After graduating from the School of Fine Arts in Quimper with degrees in art, they decided to work together and combine their individual efforts on shared projects that combine art, science, and spirituality. Jérémie Legendre was born in 1987 and graduated in 2010; he lives and works in Quimper. Timothée Peron was born in 1985 and graduated in 2010; he lives and works in Peumerit.
www.jeremielegendre.fr

UENO MASAO, architect by training, is a Japanese artist and sculptor who works mainly with bamboo. Bamboo is the signature plant of the entire continent of Asia, and Masao cuts it, weaves it, and assembles it in surprising new shapes. Masao has been working in the field since the early 1990s and is active on an international level.
www.d1.dion.ne.jp/~iueno/

DANIEL McCORMICK holds a degree in environmental design from the University of California, Berkeley. A pupil of the artist James Turrel, he specializes in environmental sculptures designed to control erosion and ecological/environmental works on the banks of rivers and streams. He uses plant materials found on-site, such as willow branches, and weaves them together to reshape banks that have decayed and eroded.
danielmccormick.blogspot.it

PAOLO MESTRINER STUDIOAZERO Paolo Mestriner (born in San Remo, Italy, in 1964) conceived and founded studioazero, a design studio in Brescia. After studying in Lisbon and Porto and graduating from the Polytechnic University of Milan, he began to accumulate research, professional, and academic work experience. He is a professor in the architecture and society department of the Polytechnic University of Milan. He conceived and directs the international master's program in extraordinary landscapes, landscape art, and architecture. He has been awarded many prizes in national and international competitions, and his work has been published in magazines in Italy and elsewhere and has been exhibited in one-man and group shows. Since 2004 he has been working on issues related to microarchitecture, in part through construction workshops in Italy, Portugal, and Norway. In May 2012 he curated the Abitare Minimo exhibit at the Maga di Gallarate museum.
ec2.it/paolomestrinerstudioazero

HEATHER & IVAN MORISON are a duo of artists who have worked together for many years. They live and work in Brighton and North Wales. Heather Peak was born in Desborough, England, in 1973. Ivan Morison was born in Istanbul, Turkey, in 1974. Since 2000 they have participated in an array of group shows and artists' residency programs. They have also created numerous installations and had individual shows. Over the years they have garnered recognition and contemporary art prizes.
www.morison.info

nARCHITECTS is an architecture firm opened in New York in 1999 by Eric Bunge and Mimi Hoang. The firm designs buildings, site-specific installations, exhibits, and interiors using flexible and responsible techniques and innovative technology. The goal is to obtain maximum effect with an economy of conceptual means and materials and with a positive impact on the environment. Hoang, born in 1971 in Saigon, studied at Harvard and MIT and teaches architecture at Yale University. She has taught in the past at the University of California, Berkeley. She has worked in New York, Boston, and Amsterdam. Eric Bunge, born in 1967 in Montreal, studied at Harvard and McGill University. He teaches at the Parsons School of Design and has worked in New York, Boston, Paris, Calcutta, and London.
www.narchitects.com

PATKAU ARCHITECTS is an architecture studio based in Vancouver. The principals are John and Patricia Patkau, and the associates are David Shone, Peter Suter, Greg Boothroyd, and Shane O'Neill. For over thirty years, Patkau Architects has developed a wide array of projects, from master planning to smaller-scale environments, to gallery installations and exhibits. Many projects have involved functional programming, management of detailed public processes, and design of complex buildings and sites.
www.patkau.ca

ARNE QUINZE was born in 1971 in Belgium and lives and works in Sint-Martens-Latem, Belgium. Although he has no formal art education, Quinze began working as a graffiti artist in the 1980's. He creates large and small sculptures, drawings paintings and large-scale installations. Sketches and drawings act as the basis of and research for his large installations. Recurring fundamentals in his oeuvre are the use of salvaged wood; electrical colors in fluorescent paint; and themes referring to social interaction, communication and urbanism. What drives Quinze is the belief in the realization of an idealistic society where all individuals communicate and interact. His installations are built to provoke reaction and to intervene in the daily life of those confronted with his sculptures.
www.arnequinze.com

RAI STUDIO was founded in 2007 by Iranian architect Pouya Khazaeli Parsa with the goal of highlighting what he considers the lost spirit of architecture. In 2000 Khazaeli Parsa earned a master's in architecture at Azad University in Tehran. He has worked with many internationally known architecture firms, including Shigero Ban Architects, Shirdel and Partners, and NJP Architects. Khazaeli Parsa is one of the best-known Iranian architects and has been recognized internationally and won several contests and prizes. RAI Studio works with partners in Tokyo, Rio de Janeiro, Sydney, and Milan, and is the Iranian base for Architecture for Humanity.
www.studiorai.com

RINTALA EGGERTSSON ARCHITECTS is a Norwegian architecture studio founded in 2008 by Sami Rintala and Dagur Eggertsson. It has offices in Oslo and Bodø. Rintala (born in 1969) is an architect and artist. From 1998 to 2003 he worked with Marco Casagrande on various architectural/artistic installations around the world. His work melds architecture with a critique and reflection of society and nature, using the language of art and using space, light, and the human body as design tools. Eggertsson (born in 1965) is an architect. He has worked for many of Oslo's major architecture firms. After earning a degree in architecture in 1992, he began to work with architect Vibeke Jenssen as NOIS architects. In 1996 he earned a master's from Helsinki University, where he started experimenting with building architectonic objects on a 1:1 scale. They teach and hold courses and workshops at various universities worldwide.
www.ri-eg.com

MASSIMILIANO SPADONI graduated from the architecture department of the Polytechnic University of Milan in 2000. He is an adjunct professor of architectonic and landscape design in the School of Architecture and Society at the Polytechnic University of Milan. He has worked with architecture firms in Rotterdam, Barcelona, New York, and Milan. Since 2005 he has had his own firm. He has received an array of prizes in international architecture and landscape competitions. Since 2009 he has taught international design and construction workshops in Norway, Portugal, and Sardinia, and as part of the XI Architecture Biennale in Venice. In May 2012 he curated the Abitare Minimo exhibit at the Maga di Gallarate museum.
ec2.it/massimilianospadoni

DOUG & MIKE STARN are American artists and twins born in 1961. They first gained international recognition at the 1987 Whitney Biennial. The Starns were initially best known for their conceptual photography work, which deals with themes and issues such as chaos, time, interconnections, and interrelations. Over two decades of artistic activity, they have continued to challenge categories and categorization, combining various disciplines, including photography, sculpture, architecture, and site-specific installations.
www.starnstudio.com

STUDIO WEAVE is a London-based architecture practice founded in 2006 by Je Ahn and Maria Smith, its principals. Architect Esme Fieldhouse, architectural assistant Eddie Blake, creative project manager Caf Fean, and architectural assistant Nina Shen-Poblete also work with the firm, which combines an open-minded, playful approach with sharp technical precision and professional engagement. It handles a diverse range of projects of various sizes. Studio Weave projects have been published extensively in magazines around the world and have received many prizes, including the Architectural Review's International Emerging Architecture Award and the Civic Trust Awards.
www.studioweave.com

STRIJDOM VAN DER MERWE, a South African artist, studied art at the University of Stellenbosch in South Africa and at Utrecht in Holland and also at the Academy of Arts, Architecture, and Design in Prague and the Kent Institute of Art and Design in Canterbury, England. A land artist, he uses materials found and recovered on-site, and his sculptures and installations take their cues from the landscape. His work process calls for using natural tools, including sand, wood, and stone. These simple materials are incorporated into the landscape, where they change and transform and, ultimately, dissolve back into it.
www.strijdom.co.za

CREDITS

Images are from the following: Al Borde Arquitectos, pp. 126–137; Ants of the Prairie, pp. 58–63; Iwan Baan, pp. 14–18; Ball-Nogues Studio, pp. 21–215; Alfio Bonanno, pp. 162–165; Marco Casagrande, pp. 138–155; Roberto Conte, pp. 156–161; Patrick Dougherty, pp. 166–171; Yolanda Gutiérrez, pp. 64–67; Porky Hefer Design, pp. 44–51; Ichi Ikeda, pp. 204–209; Kadarik Tüür Arhitektid, pp. 28–35; Jérémie Legendre, pp. 200–203; Ueno Masao, pp. 172–177; Daniel McCormick, pp. 178–183; Paolo Mestriner studioazero, pp. 184–199; Heather & Ivan Morison, pp. 36–43; nArchitects, pp. 14–27; nArchitects, pp. 19–27; Patkau Architects, pp. 52–57; Timothée Peron, pp. 200–203; Arne Quinze, pp. 90–103; RAI Studio, Pouya Khazaeli, pp. 116–125; Rintala Eggertsson Architects, pp. 184–199; Massimiliano Spadoni, pp. 184–199; Doug & Mike Starn, pp. 78–89; Strijdom van der Merwe, pp. 68–77; Studio Weave, pp. 104–115.

Grateful thanks to the following: Simona Mauri (Voliera per umani, pp. 6–9), Iwaan Baan (Forest Pavilion, pp. 16–21), Brainsik, James Ashley, Jason Strauss, Jeremy Roush (Uchronia, pp. 100–103), Arte Sella (Eremo, pp. 69, 74–77, Teatro Naturale, pp. 157–161), Aldo fedele, Giancarlo Del Savio (Teatro Naturale, pp. 157–161), Scott Mayoral, Carl Lindstrom (Yucca Crater, pp. 211–215), Arianna Forcella, Luca Poncellini, Dag Jenssen (Into the Landscape, pp. 185–193), João Cruz (Arena Selfmade, pp.198–199), Agnese Samà (ECORURALITY 2011, LAND H2O!, pp. 194–195), Guglielmo Comini (Miilu, pp. 196–197), Adam Rodriguez (Childhood Dreams, pp. 168–169), Sue Hudelson, Elyse Butler (On the Wild Side pp. 167, 170–171), Alek Sorotschynski, Andre Beneteau (Between Land and Water, pp. 162–165).

Students and design groups that participated in the labs and workshops described in this book:

Bat Tower: Thomas Giannino, Michael Pudlewski, Laura Schmitz, Nicole Marple, Mark Nowaczyk, Dan Dimillo, Matt Salzer, Jake West, Matt Bain, Albert Chao, Joshua Gardner, Shawn Lewis, Sergio López-Piñeiro, Nellie Niespodzinski, Joey Swerdlin, Angela Wu, Katharina Dittmar, Mark Bajorek, Dick Yencer.

Into the Landscape: Amin Ahmad Da'as Nataleen, Babayeva Nargiz, Baruzzi Vaj Federico, Bianchini Gaia Bin Ab Wahid Zulfadly Helmy, Brajkovic Arian, Calibè Vincenzo, Caro Martinez Felipe, Cheng Emily, De Tintis Francesco, Di Maro Daniela, Diaz Roldan Elena, Fenati Margherita, Ferrario Chiara, Ferreira Fernandes Fabricio, Fittante Silvia Laura, Forcella Arianna, Gul Aresha, Kebadze Nestan, Pesce Lucilla, Sanabria Galvis Eliana Stella, Savenko Nadezda, Usai Maria Pina, Vidari Stefano, Wimmerova Julie, Ziaei Moayyed Maedeh, Zuleta Ferrari, Arrigoni Enrico, Giancola Edoardo, Minora Filippo, Ravera Filippo, Zarattini Federico, Jakob Oredsson, Jóhannes Örn Dagsson, Stine Marie Aas Grumheden, Zulfadly Helmy, Hanna Ekstrand, Malin Therese Wik, Ieva Zule, Annick Lavallée-Benny.

Arena Selfmade: Alba Garcia, Alexandrina Costa, Alfredo Pinto, Ana Catarina Mota, Ana Lucia Lopez, Ana Luisa Marques, Ana Margarida Ferreira, Ana Rita Ramos, Ana Sara Oliveira, Andoni Diaz Torres, Andreia Rego, Bernardo Pinto, Cristiana Magalhaes, Daniela Moreira, David Coimbrat, Diana Pinto, Helder Vilares, Jessica Pereira, Joana Abreu, Joana Cunha, Joao Pedro Almeida, Josè Dias Silva, Josè Eça de Queiroz, Jurga Zenkeviciute, Liliana Alves, Maria Diaz da Silva, Maria del Carmen Reyes, Maria Inès Correia, Marco Pereira, Margarida Leal, Marta Trigo, Martyna Rajewska, Monica Couto, Nuno Sousa, Pablo Abad, Paulo Pereira, Raquel Fonseca, Raul Pereira, Sandrina Rodrigues, Sara Ferreira, Soraia Santos, Telmo Silva, Teresa Martins, Ugne Raciauskaite, Vanessa Machedo, Alexandre Jacinto, Ana Pinto, Carla Vinha, Nuno Pereira, Filipe Pinto.

ECORURALITY 2011, LAND H2O!: Abdulrazzaq Yazan Ali Ghalib, Baykova Victoria, Bagouraki Chara Evanthia, Dalia Mahmoud Lotfy El Sayed Mohamed El Saadany, D'Eramo Martina, Hun Tsai, Donyagardrad Yasaman, Kaya Ozden, Lando Francesca, Lacu Maria, Mourino Carretero, Nuri Adriana, Nardini Caterina, Nikeshina Dina, Orhan Zeynep Ipek, Ozbay Derya, Petrovic Sonja, Porras Vazquez Nataly Magaly, Rollandi Irene, Samà Agnese, Sathakku Ilyas Ahamed Hussain Ifthikarudeen, Utbjoe Pettersen Iene, Vougiouklaki Stella Maria.

Miilu: Chiara Cabrini, Michele Corno, Guglielmo Comini, Rathi Devi Easwaran, Ingvild Eikefjord, Linda Johansson Folgero, Edoardo Giancola, Angelika Huebauer, Vibeke Jenssen, Leoni Hellen Kämmer, Elina Goksøyr Leine, Ingrid Londono, Celine Marchi, Sara Omassi, Espen Steinsvik Normann, Virgile Ponsoye, Audun Reinaas, Kaori Watanabe, Yeiri Yu, Federico Zarattini.